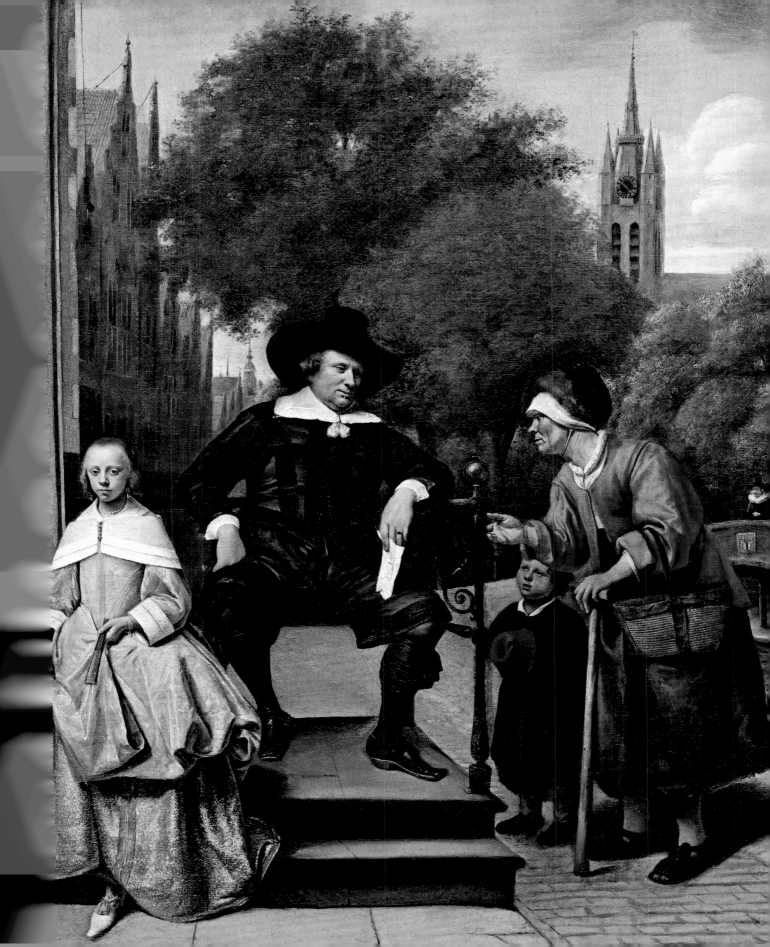

Rose-Marie & Rainer Hagen

What Great Paintings Say
FACES OF POWER

TASCHEN

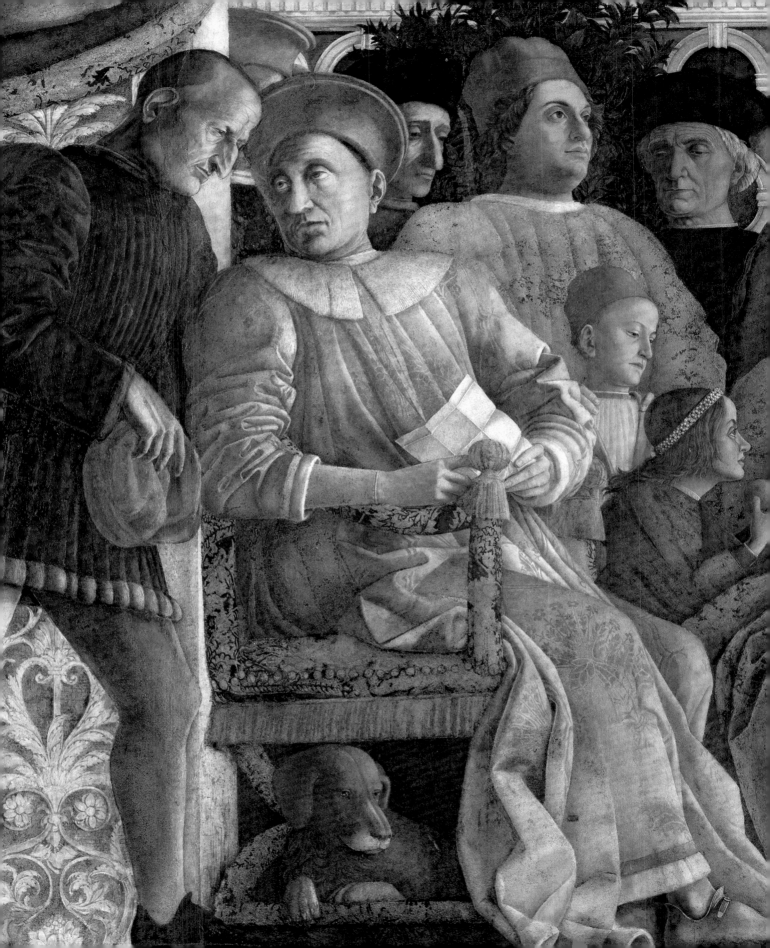

Contents

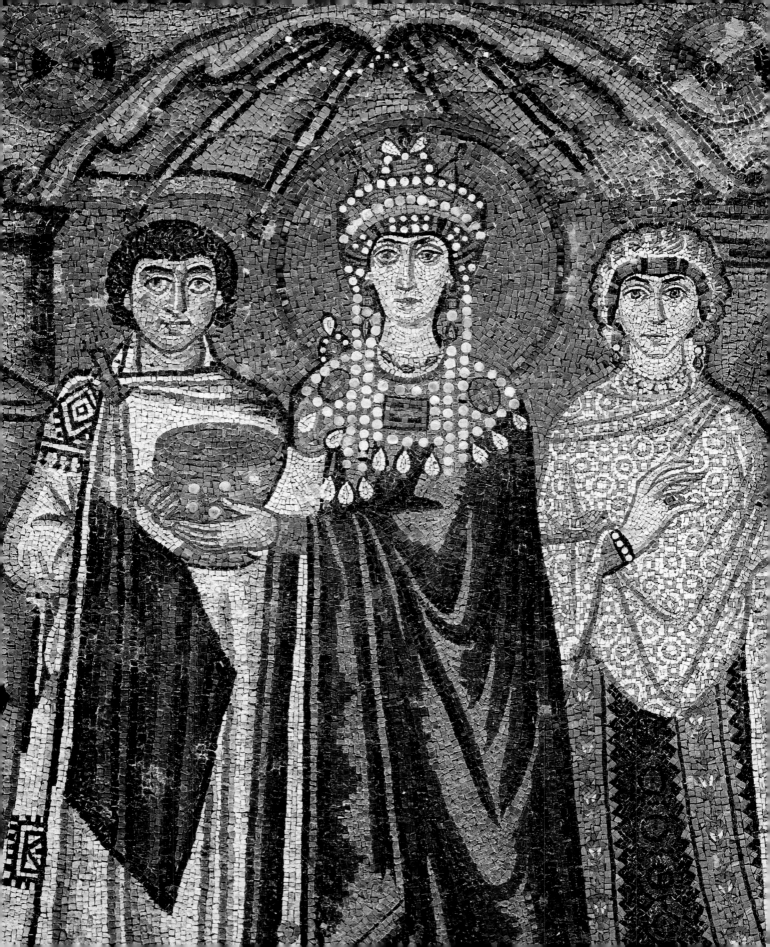

Anonymous

Group portrait with empress

The Empress Theodora with Her Retinue, c. 547
Ravenna, Basilica di San Vitale

*Whether we want to or not, we have to look up to Theodora. For her portrait is
in a mosaic high over the heads of beholders. It is in the church of San Vitale in
Ravenna. From the opposite wall her husband, Justinian, emperor of the East
Roman Empire, looks out beyond us. Theodora too bears the insignia of power,
clearly visible: the bejewelled triple diadem with the long chains of pearls,
over a jewel-encrusted cap, and over her shoulders a cloak of imperial purple.*

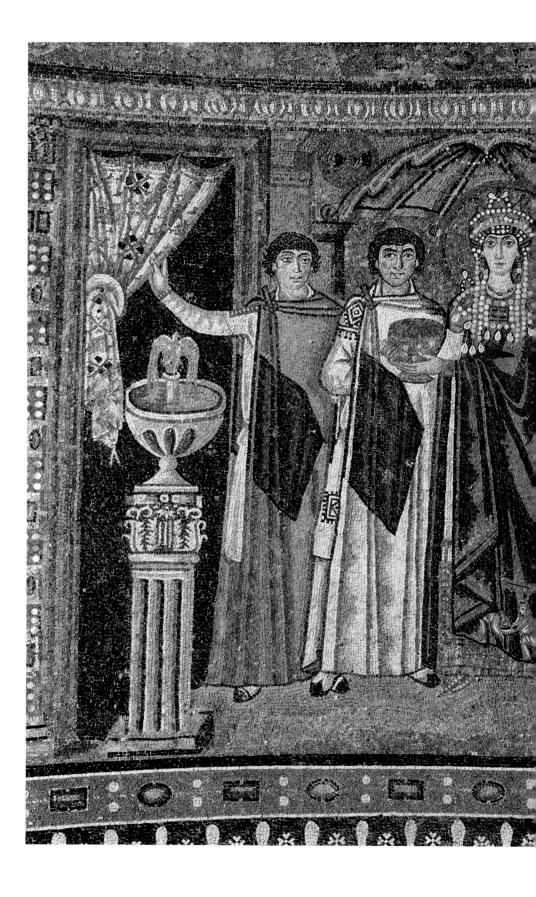

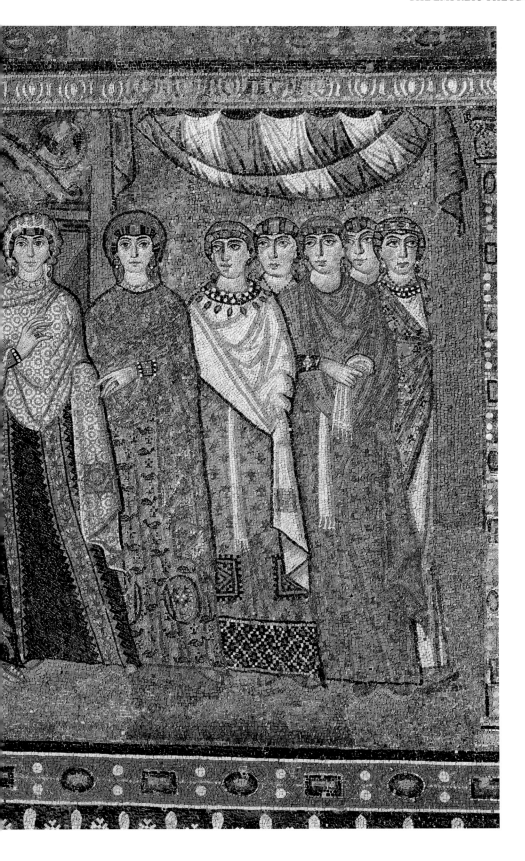

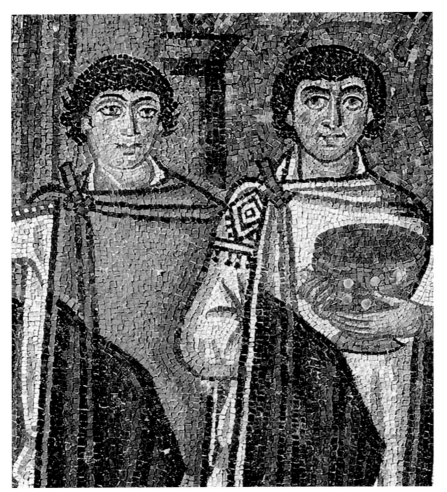

Eunuchs helped with the affairs of government

Meteoric careers were by no means unusual in mobile Byzantine society. The empress's closest confidant, Narses, probably shown here at her side, was born into slavery in Armenia in 480. Uneducated, and "a slight, to all appearances weakly man", he made his way by his appetite for hard work and his expertise, both of which he exhibited in political and military positions. Rulers could rely on him. Narses is seen in the modest attitude prescribed by etiquette, both arms concealed beneath his cloak; for it was forbidden to approach the divine rulers with "impure hands".

Both of the men portrayed in the mosaic are dressed as Byzantine officials, in the uniform of the civil administration, which was organized along military lines. The officials' belt over the white tunic is almost concealed by the long cloak fastened at the right shoulder. The rank of the wearer was proclaimed by the colour of the cloak and the large rectangular piece of material sewn onto it. This was called a tablion; the emperor's was gold, that of Narses is the precious purple reserved to the most senior of the seven ranks of official.

Even the black-and-white footwear was part of the uniform. It was part of an official's salary and was presented to him by the emperor, together with his certificate of appointment. Many officials studied law and passed difficult examinations; others, such as Narses, had a background in hands-on work. Parents who wanted their sons to rise more easily to high office had them castrated at an early age. Narses too was a eunuch. Only eunuchs and priests could not become emperor in Byzantium – and so posed no threat to the ruler.

The East Roman emperors lived dangerously, in spite or maybe because of their seemingly infinite power. They went in fear of potential rivals in high office, for they were constantly beset with court intrigues, military conspiracies and popular uprisings. In theory the ruler was elected directly by the "people"; in practice, however, it was a small military clique that voted him in.

Thus in the late fifth century Justinian was a rural lad living in a village in Thrace, till his uncle, a dependable professional soldier, was unexpectedly proclaimed emperor by the soldiery. Shortly afterwards, Justinian moved to the capital, Constantinople, where he received an excellent education and presently became the right-hand man of the ruler. This provided him

The empress is not aligned with her retinue; hers is the only figure over which no other overlaps. She is going ahead of those who accompany her, leading a procession and bearing a communion chalice to the church. An official is pulling back the drape from a portal, and the dark opening contrasts with the golden brightness of the outdoor scene. The procession is moving across an area of greenery, a fountain is splashing, and over the ladies is a colourful awning. The empress is standing exactly underneath a baldachin borne on stone columns. Although accounts describe her as short and petite, Theodora dominates her court, thanks to her foreground position and her high headdress. Protocol dictated as much to the artists who worked on this mosaic in the mid-sixth century.

The images of the imperial couple in Ravenna served a political purpose. They underlined the presence of the rulers in a city they had only recently reconquered for their empire. They were in a church because the emperor of the East Roman Empire was a religious leader and Christ's vicar upon earth. Hence the golden nimbus behind Theodora's head, a reflection of the light divine. This places her on a par with saints and apostles, quite a career for the daughter of a bear-tamer at the Constantinople hippodrome.

with the means to assure himself of the throne. In 527, on the death of his uncle, Justinian became the official successor of Caesar and Augustus, the absolute overlord of an empire still known as "Roman" although for the past two centuries it had no longer been ruled from the banks of the Tiber but from the Bosporus. Rome's first Christian emperor, Constantine, had moved his capital there in dangerous times when tribes were on the move. Before the city was named after him, it was called Byzantium.

Justinian inherited a vast empire centred on the eastern Mediterranean, united only by the Christian religion and the person of the emperor. The western territories of the old Roman empire had fallen to barbarians. When Justinian came to the throne, the Ostrogoths ruled in Rome and Ravenna. The new emperor took as his great task in life the restoration of the old borders of the Roman empire, and he succeeded; but the areas of North Africa and Italy that were conquered by his generals were lost once more after his death. The East Roman or Byzantine Empire, however, survived until 1453.

A woman well able to manage

The only certain likeness that we have of the empress Theodora is this one in Ravenna: large dark eyes, gazing from a narrow face. At this point she was no longer young, about 50 (we do not know when she was born). She died in 548, at about the same time as the church containing her image was consecrated. The portrait was copied from an original done in Constantinople, for in fact Theodora never set foot in Ravenna.

Theodora's features bear signs of illness (historians suspect cancer) or of the arduous toil of government affairs in an especially difficult time. About 540, plague spread through the East Roman Empire, taking a heavy toll on the population and ruining the economy. When Justinian too was stricken with the plague, the responsibility of government fell squarely upon Theodora. She proved well able to manage, preempting potential conspiracies and dealing with the administrative affairs of the empire as well as with military ventures – albeit not to the delight of the generals. This marked the peak of her power. For months, the empress was the absolute ruler in a patriarchal state that normally preferred her sex to be confined to the ladies' apartments. She was experienced in matters of government, since Justinian had involved her in them from the outset. This was envisaged neither by tradition nor by the constitution; but Justinian wished to share everything with the wife he worshipped his whole life long. He called her his "sweetest delight" or, from the literal meaning of her name in Greek, "the gift of God".

When he fell head over heels in love with Theodora, then a mere girl and 20 years younger than he, Justinian was already a counsellor to the emperor and in line for the throne. Theodora, by contrast, was from the lower classes. Since her early youth she had been performing on revue stages. "Fair of countenance, and graceful of form", she could neither dance nor sing, but nonethe-

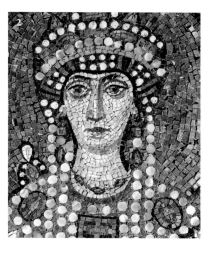

less scored immense success with her comic striptease number. In a Leda burlesque she performed with a goose that was trained to pick out grains of corn from between her thighs whilst she writhed in transports of delight. In his *Secret History*, from which we know these things, Procopius (the contemporary who also wrote the official histories) described Theodora as "the sort of girl who if somebody walloped her or boxed her ears would make a jest of it and roar with laughter". The bishop of Ephesus was even blunter: "Theodora was from a brothel."

No one, not even the church, raised any objection when the emperor's confidant fell so madly in love with this girl that he resolved to make her his lawful wife. Theodora was crowned empress at Justinian's side, and from that moment on even her arch-enemies (amongst them Procopius) could find not the slightest misdemeanour to accuse her of. She acquitted herself with dignity in her new role. She did not forget her earlier experiences, as is shown by an edict she promulgated against prostitution. Doubtless she owed her realism and tough will to the hard youth she spent in the hippodrome, the sleazy pleasure district of the capital: in 532, when whole quarters of the city were burnt to the ground in a popular uprising, and a mob besieged the palace, the emperor and his advisers were already debating flight, going into exile overseas, but Theodora, the one woman in a counsel of men, urged a fight and refused to flee. "I shall never take off the purple", she declared, "nor shall I ever see the day when those around me do not address me as the empress. The purple will make a good shroud." At her urging, Justinian's generals put down the insurrection. Some 40 thousand were left dead. Sixteen years later, Theodora went to the grave in the imperial purple.

Intrigues in the holy palace

The two ladies immediately beside Theodora cannot be identified with certainty, but while the five companions in the background are all to a similar schematic design, these two have individualized features: the elder, with the high cheekbones, may be Antonina, the chatelaine of the palace and wife of the famous general Belisarius; the younger, who bears a resemblance to her, would then be Joannina, her daughter.

Like the empress, Antonina had had quite a career on the stage; both were strong-willed women who exerted a powerful influence on their partners, an influence that their contempor-

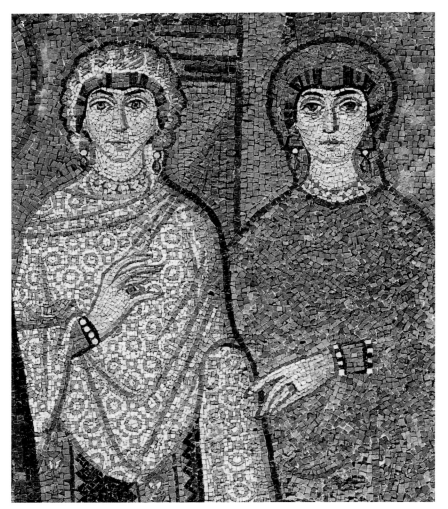

It was also Antonina who carried out Theodora's plans in Italy in 537. She accompanied her husband there, persuading the reluctant Belisarius to depose the newly and lawfully elected Pope Silverius in Rome, on the orders of the empress. The Pope was replaced by force with a favourite of the empress's. Indeed, Silverius is said to have been first banished and then murdered, by a servant of Antonina's, at the empress's command.

But charges such as these were made by Procopius, the secretary of Belisarius, who hated Theodora, or by authors who disliked her policy on religion. Her whole life long, the empress supported the Christian sect of the Monophysites, even hiding a persecuted bishop in her own apartments for years. The Monophysites were found chiefly in Egypt and Syria, and held that Christ had but one divine nature, and not an additional second, human nature, as the Orthodox Church taught. The Monophysites were persecuted as heretics, and that included the man concealed by the empress. Theodora's aim, which Justinian tolerated, was to place a Pope at the head of the Church who sympathized with her protégés. That end justified any means; and when the pontiff whom Belisarius had placed on St Peter's chair failed to satisfy her expectations too, she had him abducted from Rome and brought to Constantinople, where she could put pressure on him. Shortly before her death she seemed to be within sight of her goal: the Pope was yielding, and the Monophysites were rehabilitated. They praised the empress as "sent by God, to protect his persecuted people in the dangers of the tempest". But in fact the Orthodox Church was victorious in the long term. It was the church that wrote the history books; and Theodora was not portrayed favourably in them.

aries were at a loss to explain except by supposing them to use magic potions. Belisarius did indeed seem very much under his wife's thumb. Even on campaign he was inseparable from her; and time and again he turned a blind eye to her many blatant affairs.

If Theodora took her friend under her wing despite her scandalous lifestyle, it was not only out of loyal friendship. Through Antonina she had the popular general Belisarius, who might have been a dangerous rival for Justinian, where she wanted him. And in dealing with countless intrigues, the dependable Antonina proved her worth. In the "silken apartments of the holy palace", ably informed by a secret service organized by Narses, the two women deliberated strategies to put the empress's policies into effect and wipe out anyone who got in her way. For one powerful minister of finance, for instance, who had dared to bear tales about Theodora to Justinian, Antonina set a cunning trap: she led the unwary unfortunate to admit, with reliable witnesses listening in concealment, that he had his eyes on the throne. His fate was sealed.

Silk as a status symbol

The hem of Theodora's long cloak, worn over the bejewelled white robe, is adorned with figures embroidered in gold: the Three Kings bearing their gifts. The detail is minutely done, in coloured-glass mosaic stones of various shapes. The number of pieces used for the two imperial mosaics in San Vitale is put at 322,560, many of them gold. A thousand years on, they still shine. Bedded upon an uneven ground of mortar, they still reflect the light in manifold ways.

We know neither who designed nor who made these works, for the masters who made mosaics did not sign their

achievements. They may have been from Italy, where the Roman tradition was still alive, or equally from Constantinople. There were many outstanding Byzantine craftsmen, and throughout the Middle Ages Constantinople supplied Europe with luxury items: implements crafted of ivory, jewellery, and above all costly fabrics. Textiles were the most important sector of the Byzantine economy, assuming almost industrial proportions. But that splendorous workshop that was Byzantium produced not only for the export market (carefully monitored by customs), above all, their wares were produced for the imperial court. The exhibition of wealth was a deliberate act of policy.

"Through the beauty of its ceremonies", one Byzantine official noted, "imperial power appears a yet more splendid and magnificent thing. It makes as profound an impression on foreigners as it does on subjects of the empire." The emperor was good at the kind of show one might expect of God's vicar on earth. One contemporary poet described barbarians admitted to an audience supposing themselves already in heaven when they had barely crossed the threshold of the palace, so great was the splendour.

The protocol that set the emperor apart from mere mortals (and afforded him protection from them) extended to his clothing. Certain colour shades were reserved for the imperial family, and the death penalty could be inflicted on anyone who dared wear those shades. Tyrian purple in particular, the prized genuine purple from Tyre made from snails, was the colour of imperial garb. The shades it came in ranged from scarlet to the costliest brownish-purple amethyst hue, which has been used to dye the silk we see Theodora wearing. The fact that her neighbour is wearing a similar shade indicates her privileged status. Antonina and the other ladies of the court are furthermore wearing white patterned stoles of the latest oriental fashion. All of them, on certain feast days, received their rich clothing from the hands of the empress; for silk fabrics were a state monopoly.

Silk came from remote China, on the caravan route that crossed Persia, where the trade might be interrupted at any time. Not until years after Theodora's death did wily Byzantine monks contrive to smuggle silkworms out of China in hollowed-out walking staffs. Byzantium likewise guarded the secret of silk well, and the material remained a status symbol.

The motif of the Three Kings embroidered onto the silk is found again in the mosaics of Ravenna, in Sant' Apollinare Nuovo. There we can see clearly what we can only guess at here: the biblical magi are not entitled to the imperial purple, nor are they assigned the aura of a halo – unlike the Empress Theodora.

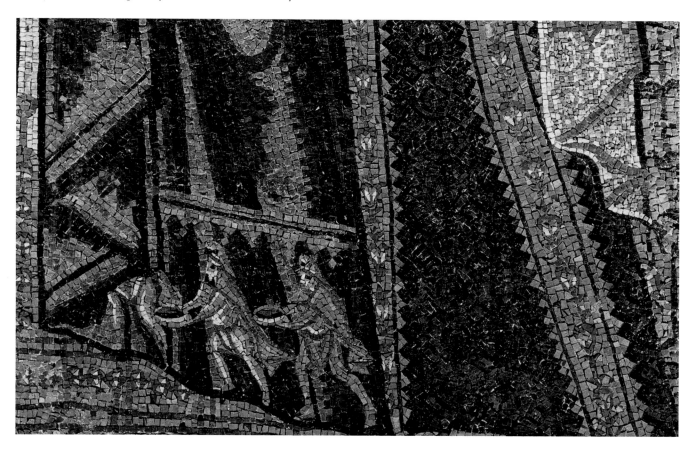

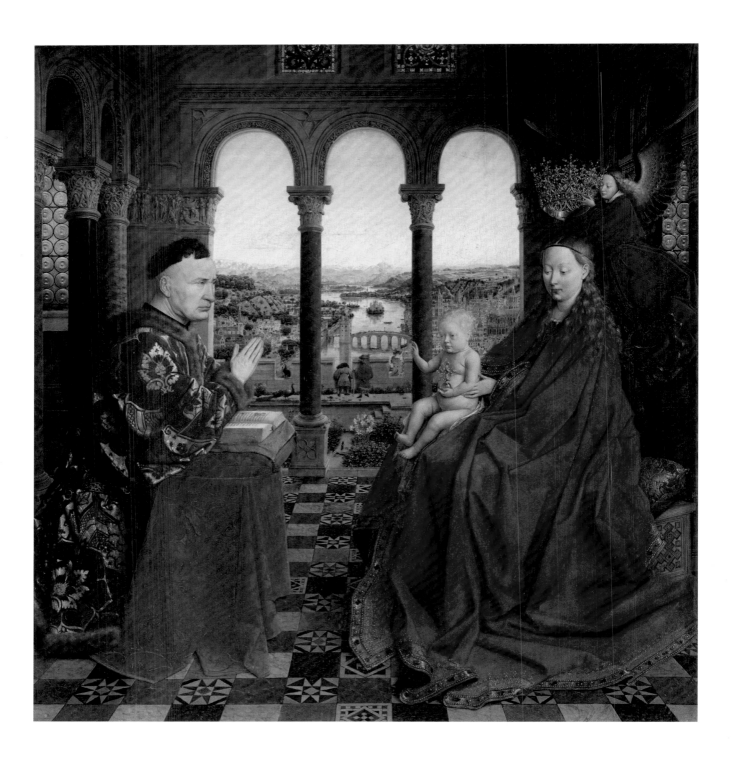

Jan van Eyck (c. 1390–1441)

May God help the chancellor

The Virgin of Chancellor Nicolas Rolin, c. 1437
66 x 62 cm, Paris, Musée du Louvre

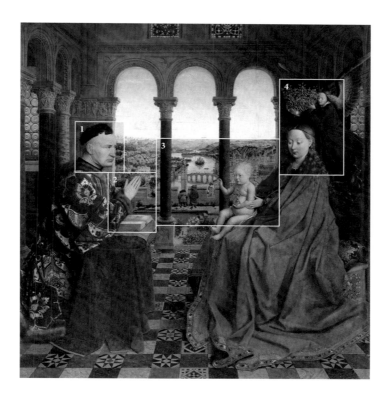

Although of low birth, Nicolas Rolin's cunning and lack of scruple helped him become chancellor of a realm. Under his strict rule Burgundy became a major European power. Rolin sought to save his soul through acts of charity and ostentatious veneration of the Virgin Mary. In so doing, he struck an equal balance between humility and pride – as the portrait shows.

His hands folded in prayer, an ageing man kneels at a prie-dieu before the Virgin Mary. An angel bearing a golden crown floats above the head of the Queen of Heaven, upon whose lap the infant Jesus is enthroned. To document his majesty, the Holy Child holds an imperial orb of crystal in one hand, while blessing the kneeling man with his other. The pious scene, intended to remind the spectator of the hereafter, is lit by the setting sun. The painting is an example of the medieval donor portrait.

However, the picture is hardly devoid of earthly lustre. The man's mink-trimmed brocade coat shimmers more opulently than the Virgin's red robe. The setting is a magnificent palace, high up in the hills. The view through the arched loggia takes in distant mountains, a riverscape, the buildings of a town – the wealth of this world.

Dating from around 1437, Jan van Eyck's painting, now in the Louvre, departs from the medieval devotional tradition in a number of important points. While these herald the dawn of a new era, they also tell us something about the person who commissioned the work. The donor at prayer is not, as was usually the case, flanked by an intercessory patron saint. Instead he kneels alone, on a level with – and the same size as – the Virgin Mary herself. Rather than cowering in self-effacing deference at the lower edge of the painting, his figure occupies the entire left half of the composition.

In the life of the man shown kneeling, worldly values had always played a more important part than religion. He had every reason to be proud: according to the contemporary chronicler Georges Chastellain, Nicolas Rolin (1376–1462), Chancellor of Burgundy, had made his lord, Duke Philip the Good, the most glorious ruler on earth.

During his 40-year period of office, Rolin expanded the boundaries of Burgundy to include an area six times as large as the original province of that name, thus creating a powerful state that was feared throughout Europe. Its foundation stone was a royal wedding in 1369: the bride's dowry was Flanders, while the bridegroom's portion was the Duchy and County of Burgundy, as well as his considerable political skills. He and his two successors profited from the ruin of France, which had been occupied and ravaged by the English during the Hundred Years' War. They created a kingdom which extended from the Swiss border to the North Sea, from Dijon to Bruges. The union of a French ruling dynasty with the spirit of the industrious Flemish and Netherlandish townsfolk prepared the ground for a highly sophisticated blend of courtly tradition and bourgeois culture.

Rolin, a Burgundian by birth, and the Netherlandish Jan van Eyck (c. 1390–1441), a highly respected court painter, were contemporaries at the court of the third duke, Philip the Good (1419–1467). Both were of non-aristocratic origin. Van Eyck had been appointed to his post for life, his main task being to "execute paintings at the behest and according to the will of the duke". Unfortunately, not one of his court paintings survive.

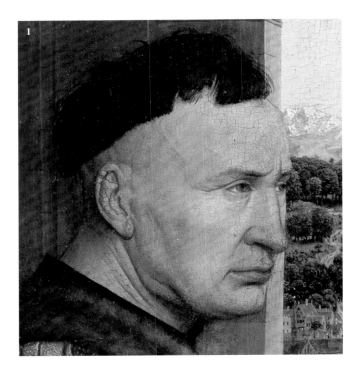

What we do have, besides several altarpieces, are a number of portraits of his contemporaries: a goldsmith, an Italian banker called Arnolfini, and Nicolas Rolin. The artist enjoyed a privileged position at court and was occasionally entrusted with political or diplomatic missions of a confidential nature. These brought him into contact with the chancellor, who, according to Chastellain, "was the supervisor of all things."

The sly fox knew no kindness

A few years after van Eyck, another Netherlandish artist painted Nicolas Rolin. Rogier van der Weyden (c. 1400–1464) portrayed him in an altarpiece as the founder and donor of the hospital for the sick and needy at Beaune, in Burgundy. Even today, the hospice receives its income from the vineyards which Rolin donated. It is hardly surprising, therefore, that van Eyck painted stone vines carved on the loggia arches, or green vineyards in the landscape beyond the chancellor.

The gaze of the man, about 60 at the time, is solemn and withdrawn. "There was not one great prince," wrote one of his contemporaries, "who did not fear him". This is perhaps surprising, since Rolin, born at Autun in 1376, was a parvenu of "humble origin". The fact that his career should have been so successful at a court known for its obsession with chivalry and etiquette is due largely to qualities proverbial amongst the Burgundian peasantry: toughness, cunning and, above all, realism. "He was very wise… in the ways of the world," wrote the chronicler. "His harvest was always of this world."

In 1419 Rolin's talents drew the attentions of the young Duke Philip of Burgundy, who had come suddenly to power following the murder of his father. Three years later Rolin was

appointed chancellor. "It was his wont to govern alone," wrote Chastellain, "and everything, whether matters of war, peace or finance, passed through his hands." The chancellor used his great authority to increase the wealth of Burgundy through inheritance, marriage and purchase of land. He was thus responsible for the annexation of Namur in 1421, Hainaut, Friesland and Zealand in 1426, and the Duchies of Luxemburg and Guelders in 1443.

However, the different parts of the kingdom of Greater Burgundy were politically disparate and geographically separate. They were held together only by the duke himself, and by the cleverness of his chancellor, who had made the centralisation and consolidation of state power his leading concern. Rolin standardized administrative and judicial practice while curtailing the privileges of both the nobility and the burghers, particularly in monetary matters. In order to finance Duke Philip's displays of pomp, the chancellor procured vast quantities of money through a never-ending series of taxes. The rebellions of Netherlandish municipalities against this enormous fiscal burden were put down mercilessly.

If Rolin was the most important man in the kingdom, he was also the most hated, mainly because of his greed. He was given to pocketing a share of the royal income, and had no qualms about accepting bribes. X-ray photographs show van Eyck originally portrayed him holding an enormous purse. We can only speculate as to what may have moved the artist to paint it over.

Hands for praying, hands for grabbing

A Book of Hours lies open on the hassock – van Eyck apparently also painted miniatures for manuscripts of this kind, already much sought after by collectors. The Book of Hours contained prayers appropriate to certain hours of the day. It is impossible to decipher the text of the open pages, with the exception of the initial D.

The chancellor's white and well-manicured hands are folded in prayer directly above the open pages. Just how fiercely these hands could strike out when it came to punishing defaulters or rebellious municipalities is documented by the French King Louis XI's remark on Rolin's charitable donation at Beaune: "It is only appropriate that one who has turned so many people into paupers while still alive should provide shelter for them after his death." In a business transaction of not entirely unusual character for the times, Rolin attempted to buy his salvation through a spectacular act of charity. A description of the deal was recorded in the hospice's founding deed of 1443.

It is possible that van Eyck's painting is intended to commemorate a specific event in Rolin's life. Its execution coincides almost exactly with a climax in Rolin's career, the signing of the Treaty of Arras in 1435. This was a political masterpiece, reversing an entire system of alliances, ending a bloody civil war between France and Greater Burgundy, and further, exacting atonement from the French king for a murder which, though unforgotten, already lay many years in the past.

Under circumstances which have never been fully explained, John the Fearless, Duke of Burgundy, had been murdered on a bridge in 1419 by the heir to the French throne, or by the latter's friends and supporters. This had provoked Burgundy to seek an alliance with the English invaders during the Hundred Years' War, helping them to occupy France. However, following years of humiliation for the defeated French, national resistance flared up again under the leadership of Joan of Arc. She had the French successor crowned Charles VII, and used his army to drive the English out of the land.

To avoid finding itself suddenly on the losing side, it was necessary for Burgundy to reverse its alliances without losing face. Rolin's achievement was to give to this complete aboutturn the appearance of a Burgundian triumph. He convened a general peace conference at Arras and, to the considerable applause of those present, disassociated himself from the English, who had decided to stay away from the conference. At the same time, the French king ceded several strategically important border towns to Philip the Good, offered a solemn apology for the murder of his father and promised several sensational acts of atonement.

There was no further mention of the girl who had prepared the ground for the treaty, however, not even by the king who owed his crown to her. She had been burned at the stake by the

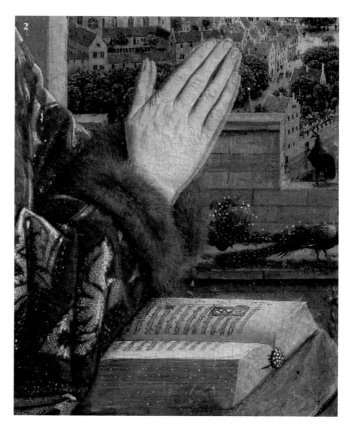

English. The Burgundian army, capturing Joan, had sold her to the English for a horrendous sum of money. It is not unlikely that part of this sum found its way into the chancellor's purse.

A kingdom at a glance

One of the acts of atonement extracted from the French by Rolin was the erection of a cross at the scene of the murder, the bridge at Montereau. A similar cross is shown on the bridge in the landscape background of van Eyck's painting. This suggests that the picture was indeed intended to celebrate the Treaty of Arras.

Many unsatisfactory attempts have been made to localize the landscape with its intricate detail and population of some 2,000 figures. The town on either side of the broad river has been variously identified as Ghent, Bruges, Geneva, Lyons, Autun, Prague, Liège, Maastricht and Utrecht. In fact, it is probably not meant to represent an authentic scene at all, but to gather together various impressions gained during van Eyck's travels. Effectively, the view thus stretches all the way from the plains of the Low Countries to the snow-covered Alps.

Only a few details can be identified: the tower of the cathedral at Utrecht, for example, or St Lambert's Cathedral at Liège. At the same time, there would have been many more wooden buildings and straw roofs at Liège than are shown in van Eyck's splendid townscape with its large stone buildings and countless spires. The latter, set in a perfectly balanced landscape, provide the appropriate background for a devotional painting, as well as for the representative portrait of a chancellor.

Perhaps the landscape is intended to show an improved version of the wealthy Burgundian towns supervised by Rolin. Or perhaps it is a higher, spiritual place: "a celestial Jerusalem", the *Civitas Dei*, the Kingdom of God, the realm of the Queen of Heaven.

The little garden beyond the portico, with its roses, lilies and magnificent peacocks, is equally ambiguous: it can be interpreted as an allusion to Rolin's luxurious possessions, or as the *hortus conclusus*, or "garden enclosed", a commonly employed symbol for the Holy Virgin during the Middle Ages. The biblical scenes carved in relief on the capitals of the stone pillars also permit a number of different interpretations.

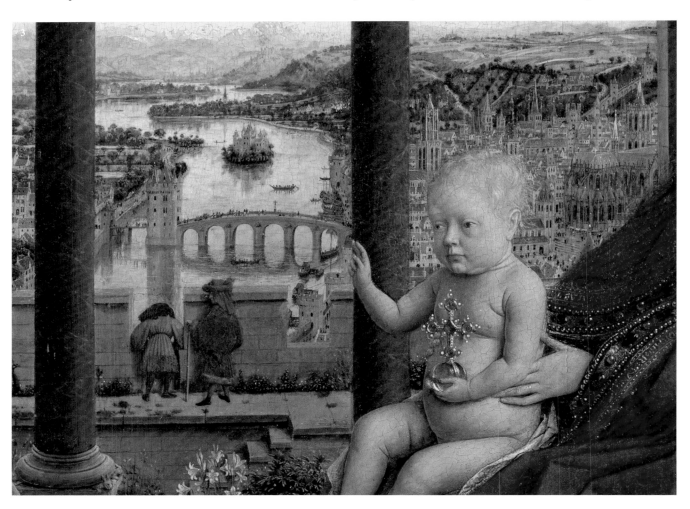

The ambiguity of the artist's "veiled symbolism" is intentional. Van Eyck was not only respected by the duke "for the excellent execution of his craft"; he was also considered a highly educated man, with some understanding of the obscurer aspects of humanistic learning. He wrote cryptographic Latin or Greek inscriptions on the frames of some of his pictures, painting hidden self-portraits as a kind of signature on others. It is therefore not entirely improbable that he painted himself and his brother Hubert as two figures leaning over the parapet at the bottom of the garden.

Shortcut to Our Lady

His honoured guest, the Holy Virgin, has settled on a modest cushion in the chancellor's portico. Her body serves as a throne for the infant Jesus, lending a gentleness to the scene, despite her crown and royal purple. Perhaps her appearance offers the sinner at prayer hope of understanding and forgiveness.

The Virgin is portrayed as a graceful young woman in eight of van Eyck's extant works: "She is more beautiful than the sun," he wrote on the the frame of one of these paintings, "and excels every constellation of the stars."

This quotation from the aprocryphal "Wisdom of Solomon" is included in the "Hours of the Virgin", a collection of prayers to the Holy Virgin which lies open in front of Rolin. In the 15th century many people said these prayers daily. Indeed, many of them, including contemporary spectators of this painting, would undoubtedly have been so well-versed in the biblical similes and flowery metaphors frequently employed to extol the Virgin that they would have had little trouble piecing together the textual fragments which may be deciphered in gold lettering on the hem of the Virgin's robe: texts dedicated to the Virgin, "exalted, as are the cedars of Lebanon", and to the glory of God's creation.

All his life, Chancellor Rolin devoted himself to obtaining the Virgin's forgiveness. In 1461 he bequeathed a silver statue of the Virgin, weighing more than 14 pounds, and a "gold crown made at La-Motte-Les-Arras" to the Church of Our Lady at Autun. Perhaps the finely wrought, bejewelled diadem presented by the angel in van Eyck's picture is an allusion to Rolin's intended donation, or perhaps Rolin's gift was copied from the painter's design, who, as court artist, would be required to have knowledge of the relevant craftsmanship.

Many documents testify to the chancellor's role as benefactor towards Our Lady at Autun. He had the church renovated and decorated and made a number of large charitable donations. Through a private passage, crossing a narrow street, Rolin was able to take a shortcut between his own house and prayers at Our Lady's. This was the church in which he had been christened, and it was here that he wished to be buried.

Van Eyck's painting was not originally intended as an altarpiece, but was hung commemoratively in the chapel where, as stipulated by Rolin's deed of foundation, a mass was to be held

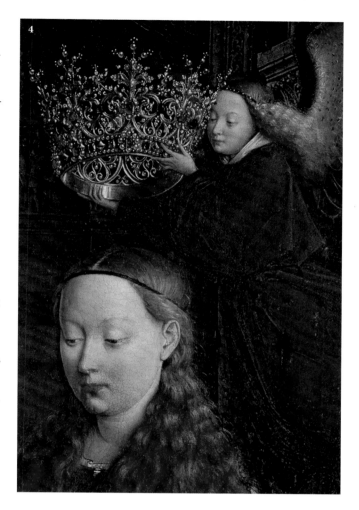

for his salvation every day until the end of time. This may, of course, be a sign of his great piety; it may, however, merely signify the shrewd precautions taken by a man of whom one of his contemporaries wrote: "As far as the temporal is concerned, he was reputed to be one of the wisest men of the kingdom; as for the spiritual, I shall remain silent."

Rolin's political life work, the state of Greater Burgundy, broke apart shortly after his death, ruined by the arrogance of its last duke, Charles the Bold. History is always the history of the conquerors: today, despite his position as one of the 15th century's greatest statesmen, and although, as the founder of an empire and loyal servant of its ruler, his stature can be compared with that of Bismarck, Rolin is practically forgotten.

His memory survives only in the work of his charitable trust, the hospice at Beaune, as well as in two works of art which, with unerring taste, he commissioned from the best two painters of the day.

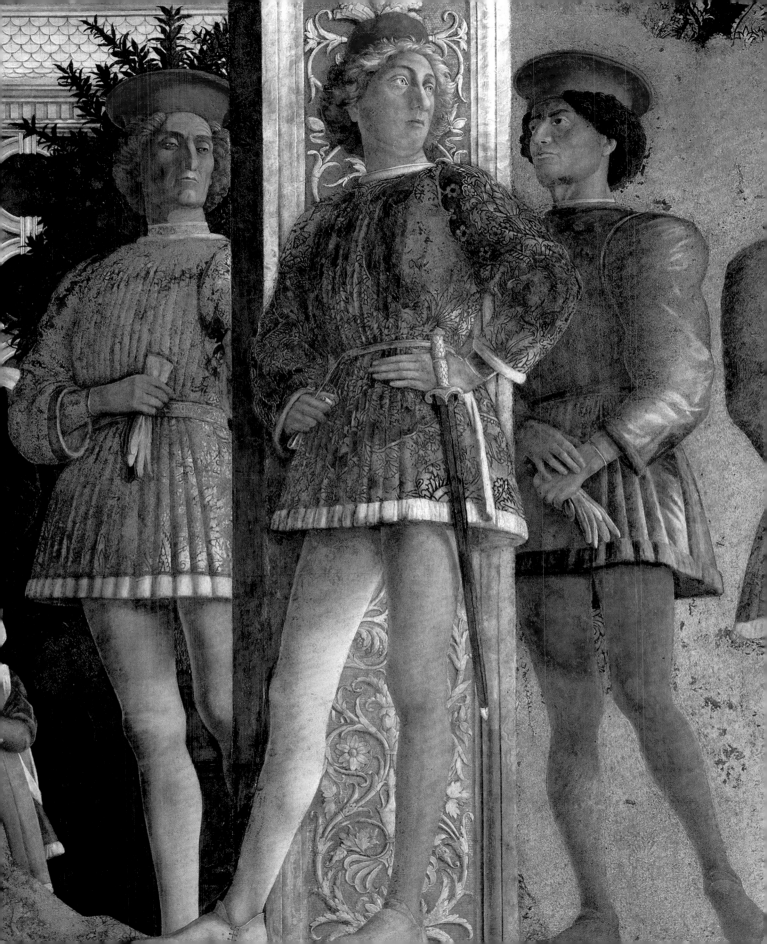

Andrea Mantegna (1431–1506)

The splendours of a small dynasty

Ludovico Gonzaga and His Family, c. 1470
600 x 807 cm, Mantua, Palazzo Ducale

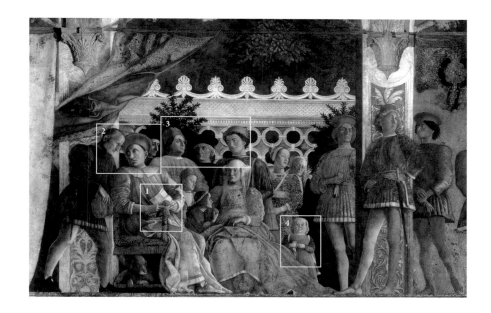

Their country was "marshy and unhealthy". They suffered from gout, malaria, rickets and a chronic shortage of cash. But the proud Gonzaga commissioned their family portrait from the "most modern" artist of their time. The fresco can still be admired in the reception room of the Ducal Palace in Mantua.

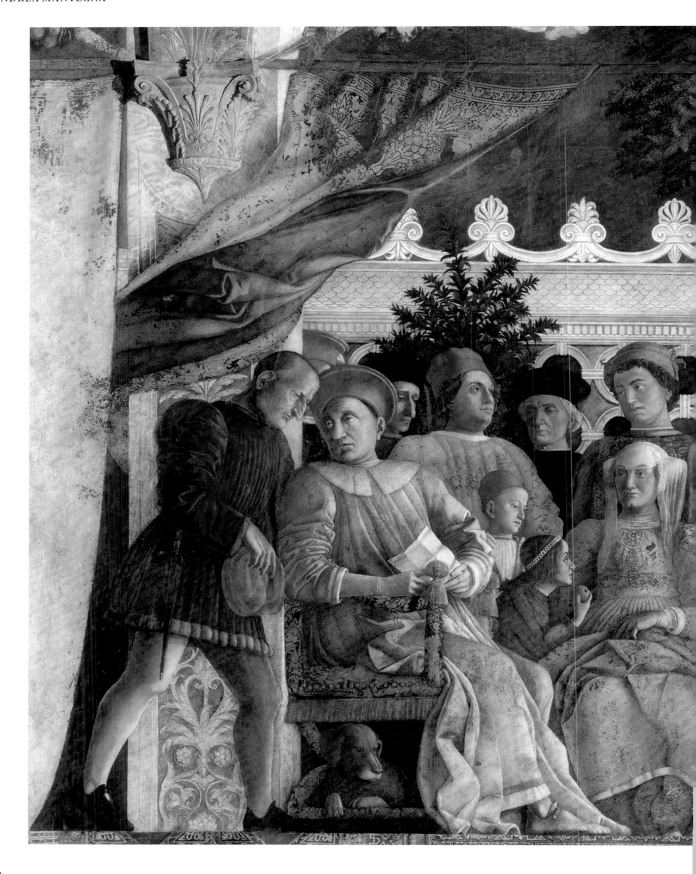

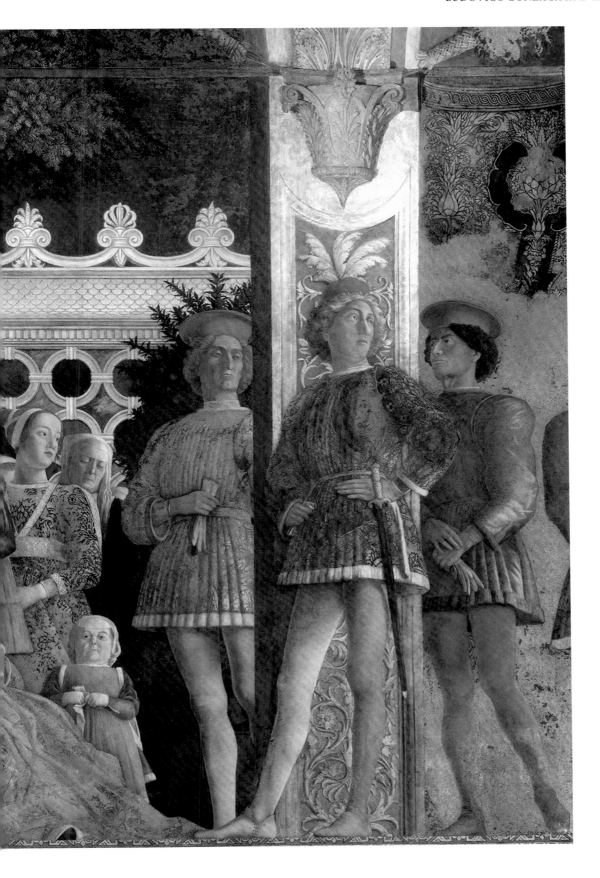

Gold-embossed leather curtains are drawn back to reveal a terrace. Here, a distinguished company is gathered before a marble screen amongst the lemon trees: the family and court of Marquis Ludovico Gonzaga of Mantua, in northern Italy.

Only the reigning couple can be identified beyond doubt. Ludovico is shown with a letter in his hand, conferring with a secretary. Marchioness Barbara of Brandenburg has a little daughter at her knee; behind her may be one or two of her ten children. The sombre officials in their dark clothes contrast starkly with the arrogant-looking courtiers, possibly Gonzaga bastards, or masters of ceremonies. They wear stockings in the red-and-white of the reigning house. Rubino, the marquis's dog, and a dwarf complete the family portrait.

The Gonzaga, dressed in luxurious, gold-spun cloth and blessed with many children, present the image of a confident, successful clan. In the middle of the 15th century, the family had experienced a sharp upturn in fortune. In 1328, one of their predecessors, a simple but nonetheless wealthy land-owner, had risen to the position of "Capitano" of the city of Mantua. The family had succeeded in retaining its foothold, amassing power and finally adding legitimacy to its position through the purchase of a ducal title from the emperor.

By the standards of the wealthy Florentine Medici, the in-come of the Gonzaga was limited. Their small territory on the Lombard plains was modest by comparison with the powerful states of Venice or Milan. Pope Pius II gave a bleak description of Mantua in 1460: "Marshy and unhealthy … all you could hear were the frogs." Ludovico Gonzaga decided to find a rem-edy for this: he not only had the marshes drained and the town squares paved over, but did everything he could to attract the best architects and artists to his court.

The architect and early Renaissance theorist Leon Battista Alberti (1404–1472) designed churches for the marquis in the very latest style – after the model of antique temples. In the Ducal Palace Mantegna's frescos transformed a relatively small reception room, later called – for unknown reasons – the Camera degli Sposi or Bridal Chamber; his illusionistic paint-ing appears to extend the real space of the room via the ceiling into the sky, and through the walls on either side into a terrace and landscape.

Three years to engage a painter

The writing on the sheet of paper held in Marquis Ludovico's hand could tell us something about the occasion for the group portrait, which was probably commissioned to com-memorate a particularly significant event. Since it is impossible to decipher the letter, we can only speculate. What is certain, however, is that it bears testimony to a favourite pastime at the court of Mantua: the writing, reading and preservation of manuscripts. Owing to the work of countless clerks and secretaries, a huge archive and precise record of the most important events in Mantua has been passed on to posterity. The life of the painter Mantegna, who spent 46 years there, is thus more thoroughly documented than the life of any other artist of his time.

The documents begin in 1457 with the voluminous corres-pondence undertaken to attract the 26-year-old painter to Mantua. Marquis Ludovico spent three years attempting to engage him. Andrea Mantegna (1431–1506) had made a name for himself with frescos in Padua. Their bold use of perspective and confident return to recently discovered antique models astonished his contemporaries. It was said that his portraits showed the sharply defined contours of Roman coins. Ludovico was determined to attract this exciting, modern man to Man-tua, which lacked its own artistic tradition at the time. At least he could boast the presence of one other innovator: the Floren-tine architect Leon Battista Alberti had recently been entrusted with the building of churches and palaces.

Mantegna was hesitant to assume the obligations that ac-companied the position of court painter. These included a vast amount of time-consuming, routine work: the decoration of country houses, the planning and staging of court festivities. Moreover, if the testimony of the Pope could be believed, Man-tua was hardly an attractive proposition. What could be used to entice Mantegna? For one thing, the sum, agreed by letter, of, "180 ducats per year, a house to live in, enough wheat for six persons and firewood". Owing to their chronic lack of money, the Gonzaga payments were often overdue (because of this, Mantegna was later forced to write countless reminders and requests for payment). The Lords of Mantua found it much easier to reward their ambitious painter with status symbols.

In the course of the years, they conferred upon him the fine-sounding titles of Count Palatine and Knight of the Army of Gold.

The real reason for Mantegna's decision to go to Mantua in 1460 was probably the marquis's cultivated understanding of art, his ability to appreciate the innovations of the Renaissance and, not least, the solicitous attitude exhibited by this busy ruler towards the artists in his service, a quality also documented in the correspondence.

In 1465, for example, the marquis personally ordered "two cartloads of lime with which to paint our room in the castle": frescos were painted on a ground of fresh lime. In 1474 he sent for gold leaf and lapis lazuli, paints so precious that they were usu-

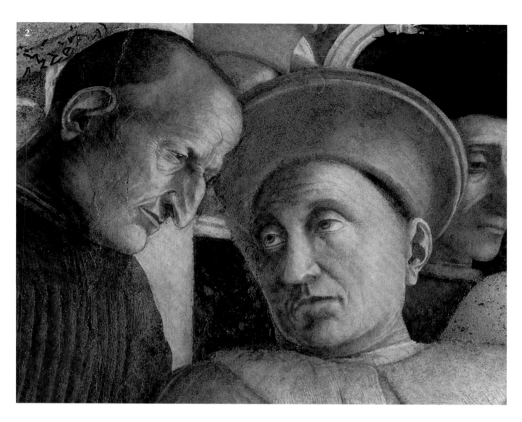

ally added only as a final touch. These letters were separated by nine years, during which time Mantegna was evidently decorating the Camera Picta, or Painted Room, for the renovated palace. For in 1470 Ludovico complained about the slowness of the artist, "who started to paint the room so many years ago, and still has not completed half of it".

A cunning man of peace

Marquis Ludovico's stockingless foot wears a slipper, and his simple housecoat contrasts with the ostentatious gold thread of his family's dress. When Mantegna finally completed his frescos in 1474, the potentate was 62 years old, worn out by 30 years of government, and in ill health. Ludovico had held highest military office. Initially serving the Venetians, he had eventually become general commander for the Dukes of Milan, a position he maintained for 28 years. His reliability and loyalty towards those he served contrasted favourably with the vast majority of condottieri, the mercenary generals paid by Italian princes to fight their wars. Unlike his peers, he was not interested in booty, nor in war as an art. Ludovico was a man of peace. He did not owe high military rank to martial prowess, but to the geographic and strategic position of his small state.

The River Po, used for transporting goods, flowed directly through the land of the Gonzaga. Mantua also controlled the approach to the Brenner Pass. Connecting Italy with the north, this was one of Europe's most important trading routes. Mantua, protected on all sides by water, was considered im-

pregnable. The rival neighbouring powers of Venice and Milan therefore attempted to secure an alliance with the marquis, or at least his neutrality, and he was clever enough to play the two off against each other.

In order to achieve a certain degree of independence from both powers, the Gonzaga sought foreign support by marrying beyond the Alps. Ludovico was married to Barbara of Brandenburg, a relation of the emperor. For his heir, he himself chose a bride from the House of Wittelsbach. He maintained good neighbourly relations with Venice and Milan, and always commanded the army of whichever was prepared to pay him most. His wage as a condottiere, in reality a disguised reward for his alliance, was considerable – indeed it would occasionally exceed the income generated by his entire kingdom.

Without a separate, external income he could never have afforded such a lavish lifestyle at home. His princely suite would sometimes comprise more than 800 people. He also had an expensive hobby: horse breeding. Of course, his Milanese ducats also permitted Ludovico to patronize the arts, to commission buildings and paintings. His investment proved worthwhile. Shortly after Ludovico's death, a man who was probably the greatest art expert amongst the Renaissance princes, Lorenzo de' Medici, also known as the Magnificent, travelled specially to Mantua to admire its paintings and collection of antiques. Out of a swamp where "all you could hear were the frogs" had arisen a town whose fame, within a mere 20 years, had spread far and wide.

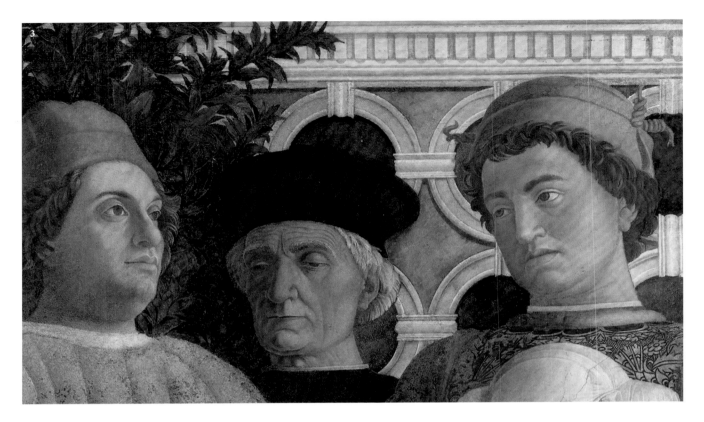

A teacher who formed Renaissance Men

The white-haired man standing between two of Marquis Gonzaga's sons had been dead for some time when Mantegna came to paint his frescos. Vittorino da Feltre owed his place in this fresco to the gratitude of his former pupil. Without him, Ludovico Gonzaga would probably never have become quite such a remarkable ruler.

Vittorino da Feltre (1378–1446) came to Mantua in 1423 as a teacher and court librarian. His pupils included not only Ludovico and his siblings, but also Ludovico's future wife, the German Barbara of Brandenburg, who had come to the Gonzaga court at the age of ten. With Vittorino's help this unattractive, but by all accounts clever girl became a ruling lady, fully capable of governing the state when her husband was away commanding foreign armies.

The reputation of Vittorino's "School for Princes" attracted pupils to Mantua from all over Italy, and many important figures of the Renaissance were educated there, amongst them Duke Federico of Urbino. All lived together, with 60 poor, but gifted pupils who received a scholarship from the Gonzaga, in Vittorino's "Ca' Zoiosa", or "house of joy". The contrast between this more modern institution and the grim monastic schools of the Middle Ages, where pupils had lived under the rule of rote learning and the cane, was not solely atmospheric. Vittorino's educational ideas, derived from Classical models, were revolutionary for their time. He paid great attention to physical education, for example, and attempted to awaken in his pupils both a Christian sense of duty and a healthy respect for Classical virtues. His ideal was the *uomo universale*, combining vigour and spirit to form a harmonious whole.

Ludovico Gonzaga came very close to Vittorino's educational ideal. He was an intellectual of high artistic sensibility, and a man of action who was single-minded in improving the fortunes of his family and town.

The marquis owed his political success to an inspired move: in 1459, following extensive preparations, he convened a conference of sovereign princes at Mantua, attended by the pope and dignitaries from both sides of the Alps. Although this plunged Ludovico into debt for many years, it gave him an opportunity to spin the threads of a cardinal's robe for his second son Francesco (1444–1483). Following Francesco's elevation to the rank of cardinal in 1462, Ludovico greeted his son, according to one of his contemporaries, "with tears of joy"; it is possible that this was the triumphant occasion Mantegna's painting was intended to record. The paper in Ludovico's hand may be a letter of appointment bearing the papal seal.

Ludovico's two eldest sons, standing to the left and right of Vittorino da Feltre, although not educated by the great teacher himself, were brought up in his spirit. Cardinal Francesco, on the left, laid the foundations for a famous collection of Classical antiques. His older brother Federico, Ludovico's heir, despite spending the greater part of his few reigning years (1478–1484) on battlefields, was also a patron of the arts. Mantegna even worked under a third generation of Gonzaga. Ludovico's

grandson, Francesco (1466–1519), had great respect for him: "an extraordinary painter, unequalled in our time." He, too, had learned that "a ruler becomes immortal by knowing how to honour great men." It was a lesson Vittorino da Feltre had taught Francesco's grandfather.

Gout, malaria, rickets: complaints of the Gonzaga

Dwarfs and other human freaks were much sought after as court fools; at some Renaissance courts they were systematically "bred", a practice otherwise restricted to dogs and horses. Duchess Barbara is said to have kept two female dwarfs, Baby Beatricina and Maddelena the Midget, to entertain her. However, more malicious tongues have it that the dwarf in Mantegna's fresco was a daughter of the reigning couple. The proud ruling family of Mantua – according to retrospective medical diagnosis – not only suffered from gout and malaria, but also from arthritis and rickets, which often led to curvature of the spine.

The boy and girl at the duchess's knee look pale and thin; only two of ten children enjoyed perfect health. Two, including Cardinal Francesco, suffered from obesity; one had rickets, and four, amongst them Ludovico's heir Federico, had an unmistakably hunched back, although the fresco hides this. Since little is known of the remaining Gonzaga children, it cannot be excluded that they were dwarfs.

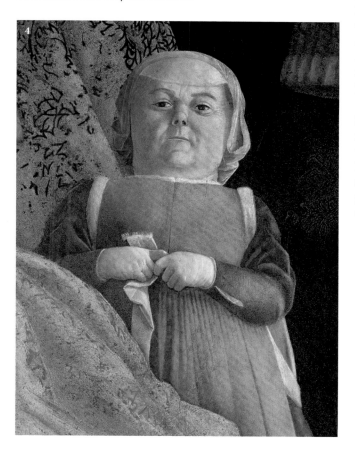

The defect probably entered the family through Ludovico's mother Paola Malatesta, who had come to Mantua from the renowned ruling house of Rimini. Two of her children were deformed, and even her eldest son Ludovico hardly demonstrated Vittorino da Feltre's ideal of a healthy mind in a healthy body. He suffered from obesity, and was often ill. It was possibly only the strict diet and regular exercise imposed on him by his teacher that prevented him from developing curvature of the spine as well. His heir Federico was not so lucky: he was described by one of his contemporaries as an "amiable, engaging man with a hump".

The Gonzaga bore their ailments with composure, accepting humiliation when necessary. In 1464 the Milanese heir, Galeazzo Maria Sforza, refused to marry Ludovico's daughter Dorotea with the words: "These women, born of the blood of hunchbacks, only give birth to new hunchbacks and other lepers." His first engagement, to Dorotea's elder sister Susanna, had been broken off at the first sign of her developing curvature of the spine. Susanna had thereupon entered a convent, leaving Dorotea to take her place as the Sforza heir's bride. But as soon as the opportunity of a more advantageous match arose – with an heiress from the house of Savoy – Sforza made public his feelings of disgust for the Gonzaga.

The insult threatened to cause a reversal of existing alliances, almost driving Ludovico into the service of Venice. In the end, however, the link with Milan proved stronger; over the years the marquis had become "like a son … like a brother" to successive dukes: a true "guardian of the state of Milan". On three separate occasions, when the fate of the troubled house of Sforza lay in Ludovico's hands, the loyal general commander hurried to their immediate aid.

Perhaps Ludovico Gonzaga took secret revenge on the Sforza family by commissioning Andrea Mantegna to paint a fresco showing the moment of triumph when a missive containing a cry for help had reached him from the impertinent Milanese. Of course, he would not grant the Sforza name itself a place in the picture, for they were to have no part in the immortality which the lords of Mantua hoped to secure for themselves through Mantegna's art.

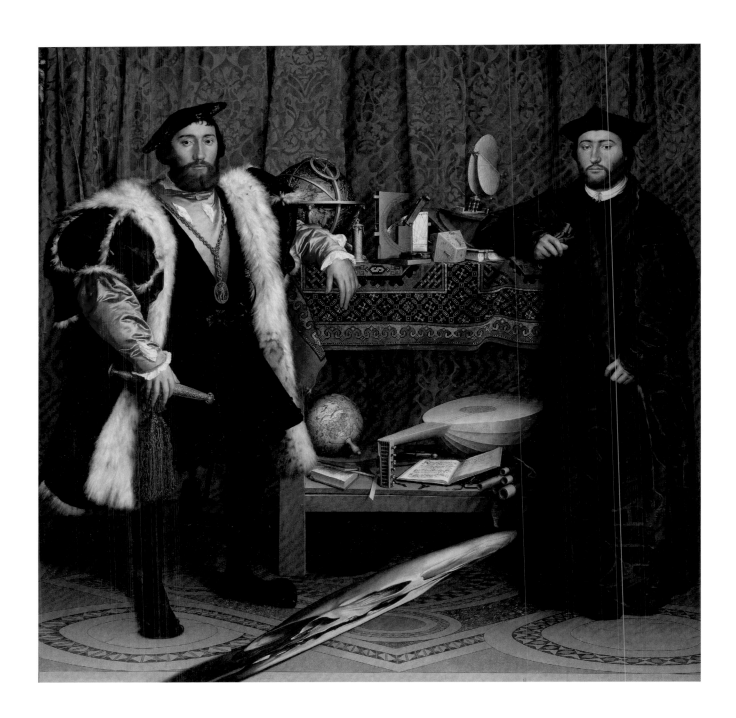

Hans Holbein the Younger (1497/1498–1543)

Careers in the king's service

The Ambassadors (Jean de Dinteville and Georges de Selve), 1533
207 x 209.5 cm, London, The National Gallery

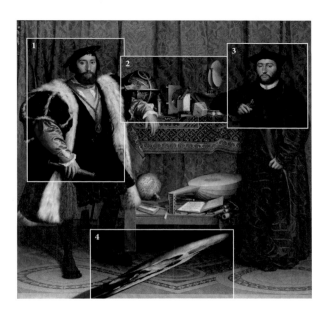

A young French bishop visits a young French diplomat in England.
They were friends, and the artist shows us some of the interests they shared:
music, mathematics, astronomy. Death, too, is concealed in the painting.

An official portrait: two men whose bearing, respectability and earnest mien make them look about 40 years old. But they were both much younger; the man on the left was 29, the man on the right 25. Life expectancy in the 16th century was shorter than today; people tended to enter important posts at an earlier age. One of the men is already a bishop, the other is French ambassador to the English court.

The churchman, himself occasionally entrusted with ambassadorial duties by the French king, is visiting his friend, the diplomat. The two represent different sectors within the diplomatic corps, named after their styles of dress: *l'homme de robe courte* and *l'homme de robe longue*. Men of the short robe were worldly ambassadors; those with long robes were clergymen.

To be sent on a diplomatic mission by the king was an honour, but seldom a pleasure in the 16th century. Above all, it was expensive. The king granted fiefs, benefices and allowances to both clergy and nobility. In return, they were obliged to perform services, a duty extending to the disposal of their incomes. They were expected to pay for their stay in foreign lands out of their own pocket. Once there, they were generally treated with due politeness, but also with suspicion. Diplomats were thought to combine their official duties with spying. In 1482, for example, it was strictly forbidden for Venetians to talk of public affairs to foreign diplomats; and one Swiss ambassador reported from London in 1653 that a member of parliament who spoke to a foreign ambassador risked losing his seat. Certainly, it was one of the ambassador's main tasks to collect as much accurate information as possible about the country he was visiting. Newspapers did not exist at the time.

Contemporary manuals and memoirs give us some idea of the abilities expected of a diplomat. First of all, he should cut an appropriately representative figure, wearing clothes that were fine enough, and expensive enough, to be worthy of his master. He should be eloquent, have an excellent knowledge of Latin (the lingua franca of the day), and be educated to converse with scientists and artists. His manner should be urbane, charming, never too curious; he must be able to retain full composure while listening to the worst of news, and be skilled in slowing down or speeding up negotiations whenever necessary. His private life should be impeccable, precluding even the slightest hint of a scandal. His wife must stay at home, of course; after all, she might gossip. It was considered of the utmost importance to retain an able cook; good food is often a ticket to the best information.

The 16th century was the cradle of modern diplomacy. Previously, the affairs of European states in the Holy Roman Empire had been regulated centrally by the Emperor. This system had lost much of its authority. Instead, bilateral agreements had grown in significance, and with them the art of diplomacy. However, permanent embassies remained an exception; diplomatic missions lasted only a few weeks or months. It was not yet essential, as it later became, for foreign policy to direct its energy toward establishing relationships of mutual trust over long periods. Short-term success was more important. If a contract no longer served a country's interests, it was broken. These were times of great insecurity. The balance of power changed from month to month. There was one means alone of securing an alliance of real duration – marriage.

The changing structure of alliances in the 16th century is reflected in its record of engagements and their dissolution, its history of marriages and their annulment. As a young man, the English king Henry VIII had married Catherine of Aragon. She was an aunt of the powerful Spanish king, Charles V. Henry and Catherine had a daughter, Mary, who herself became engaged to Charles V of Spain. However, while Mary was still a child, Charles V dissolved his engagement to her, for he wished to marry Isabella, the Infanta of Portugal, a match which would directly increase his wealth and sphere of influence. Henry, meanwhile, in whose opinion Charles V was becoming altogether too powerful, sought to ally himself by marriage with France. Before remarrying he needed the pope to declare his marriage to Catherine null and void. But the pope had been dominated by Charles V since 1527. He was therefore unable to annul Henry's marriage. The matter was made even more complicated by the Privy Council, who wished to see the English noblewoman Anne Boleyn, rather than a French princess, on the throne of England.

It was against this background, in the spring of 1533, that a French ambassador was sent to London. While there, the diplomat had his portrait painted in the company of his friend. Hans Holbein documents the execution of the painting on English soil by means of the mosaic on which his subjects are standing; the design is that of the mosaic laid by Italian craftsmen in the sanctuary floor at Westminster Abbey. Today, the floor is heavily worn and covered by a large carpet. Only at the carpet's edge is it possible to see the original ornamental work.

Nobleman on a delicate mission

The French ambassador is Jean de Dinteville. Born in 1504, he resided at Polisy in Champagne. As a manorial lord, he had the right of jurisdiction; he was also King's Proxy at the provincial capital of Troyes, an office held by his father before him. Jean de Dinteville did not belong to one of the great noble families of the land, nor was he one of the great historical figures of his time. He was, however, an archetypal Renaissance nobleman: a humanist with an interest in music, painting and the sciences. He was active in the king's service, and dependent on the king's goodwill. His greatest gift to posterity was his decision to have himself portrayed with his friend by Hans Holbein.

The artist portrays the nobleman with the Order of St Michael hung on a long golden chain around his neck. This was the French equivalent to the Spanish Order of the Golden Fleece or the English Order of the Garter. The 16th-century royal orders had nothing to do with the orders of the late Middle Ages, brotherhoods dedicated to a way of life combining monastic and chivalric ideals. Instead, they were a means of

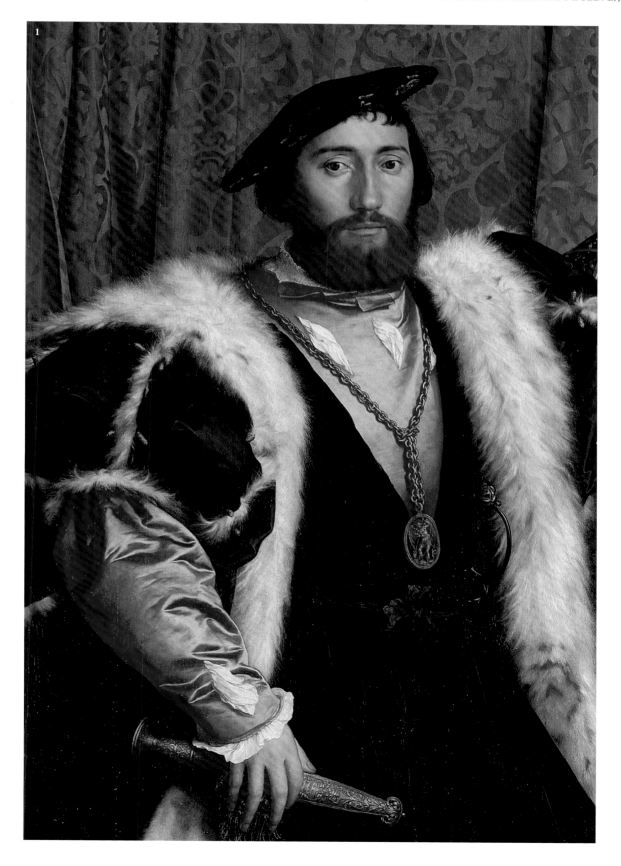

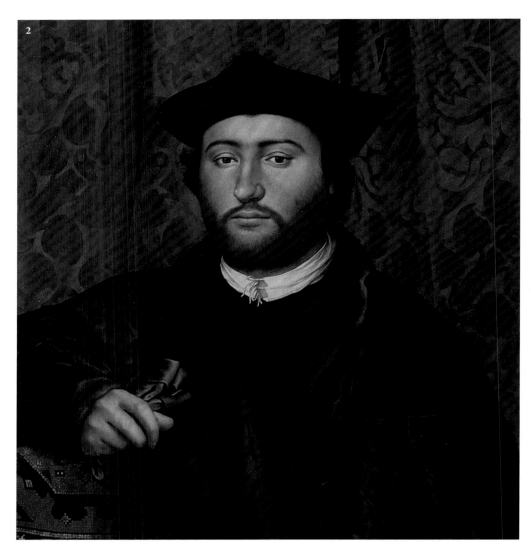

On 23 May 1533, Dinteville informed his master by letter that he had asked Henry VIII "if it should please him to make a secret" of the archbishop's decision, "so that our Holy Father is not informed of this matter before Your Majesty speaks to him of it. He replied that it was impossible to make a secret of this, and that it must be made public even before the coronation."

Anne Boleyn was crowned at Westminster Abbey on 21 June. High honours were conferred upon the French ambassador during the festivities that followed. In the meantime, however, the subject of negotiations between Dinteville's sovereign, Francis I, and the pope had changed: the French king now sought to marry his son to the pope's niece. His aim was to win over Milan. Henry's interests were forgotten. There was therefore little left for Dinteville to do in London. He left on 18 November 1533.

endorsing the allegiance of a loyal subject, awarded to capable men in the hope of ensuring their devoted service to the throne. Their prestige derived partly from their limited membership. There were only one hundred holders of the Order of St Michael at any one time.

Francis I, the French king, had sent Jean de Dinteville to London for the first time in 1531. In the spring of 1533, he was sent to London again, for in the meantime, the alliance between the two countries had become even more confused. Henry VIII had secretly married the pregnant Anne Boleyn in January, though the pope had not yet annulled his previous marriage.

Francis I offered to use his influence in the Catholic Church on Henry's behalf. A meeting was arranged between Clement VII and Francis I; but Henry procrastinated. He had the Archbishop of Canterbury declare his old marriage null and void, thereby encroaching upon papal rights. He obstructed negotiations between the French king and the pope.

Dinteville was present in London not only for Anne Boleyn's coronation, but also for her execution. He was entrusted with three further diplomatic missions to England, before his family fell into disgrace. Apparently, his three brothers had plotted against Francis I. Jean de Dinteville died, aged 51, at Polisy. Before his death, he conducted renovations at his castle, employing – like the English kings and Francis I – Italian craftsmen to execute the work.

A tiled floor in the Italian style exists at Polisy to this day. Holbein's painting hung at the castle for many years. Today it is in London's National Gallery.

A pious man fears for the Church

Unlike his worldly friend, the bishop does not hold an ornamental dagger in his right hand, but a pair of gloves. His arm rests on a book, on whose fore-edge part of a sentence may be deciphered: *aetatis suae 25*. If we add the word anno, the sentence, rendered into English, reads: "in the 25th year of his life".

Dinteville's age, incidently, is written on his dagger. Facts like this helped identify the figures. The bishop was Georges de Selve.

As can be expected from a representative portrait of this kind, the subjects' faces are almost expressionless. Without their different styles of beards, the two friends might even look quite similar. Their eyes, on the other hand, are distinctive. Those of the bishop are smaller, with their pupils more heavily shadowed by the lids. Accordingly, the bishop does not appear to concentrate quite so intently on his immediate surroundings as the worldly ambassador. A similar distinction may be made in respect of their dress and bearing. Dinteville's puffed up fur makes his shoulders twice as wide as those of his friend. The diplomat wears his fur coat wide open; the clergyman is holding his coat so that it completely covers his body. The life of one is more outward-going, the other's more introspective. Their different personalities allow Holbein to characterize two castes: *robe courte, robe longue.*

Georges de Selve's father, president of the Parlement de Paris, had been rewarded for his many services to the crown by the bestowal of a bishop's fief upon his son. Georges, then aged 20, was made Bishop of Lavaur in the southwest of France. Although the minimum age for this office was 25, a dispensation from the pope rendered exceptions possible. These were frequent enough. Bishops who were too young for office received an income and title, while their clerical duties were performed by priests.

Even after Georges de Selve was permitted to take up ecclesiastical office, he spent most of his time outside his diocese. In the autumn of 1533, following a private visit to London, the French king sent him as an ambassador to Venice; later, he was entrusted with a mission to the pope in Rome, and then to Charles V in Madrid. In 1540 de Selve requested to be relieved of his offices for reasons of health. In April of the following year he died, aged 33.

Georges de Selve's writings bear testimony to his piousness. He saw the solution to the problems of his time, including those of a worldly nature, in a total regeneration of religious life. He criticized not only the condition of the Church, but also the selfish machinations of kings and princes. De Selve evidently had some sympathy for Luther's endeavours as a reformer; he nevertheless opposed the division of the Church. In all probability, de Selve was France's delegate at the Diet of Speyer in 1529, holding a great speech there in favour of confessional reunification.

Holbein refers to the notion of reunification by means of a hymnal lying open on the lower shelf. The book is neither French nor English, but the German Johann Walther's Book of Hymns, printed at Wittenberg in 1524. The book lies open at two of Luther's hymns: "Kom̄ Heiliger Geyst Herregott" and "Mensch wiltu leben seliglich". The first is a German translation of "Veni Creator Spiritus", the second points to

the importance of the Ten Commandments. In content and tradition both are good "Catholic" texts, emphasizing the common ground between the new Lutheran and old Roman Catholic standpoints.

Central role of mathematics

The figures portrayed in 16th-century double portraits are usually shown close together. Not so Dinteville and de Selve. Holbein sets them as far apart as possible, placing them right at the edges of the painting. Between them, a plain, two-storeyed cupboard displays a large number of books and instruments. It is almost as if Holbein wished to indicate that the bachelors' friendship was based on a common interest in natural science.

All of the instruments are linked in some way or another to applied mathematics. On the left there is a celestial globe; next to it, a cylindrical sundial, or shepherd's timekeeper. There are several sundials on the faces of the polyhedron; these were used for travel. Then there are two different types of quadrant, and on the lower shelf a small, portable globe, a level, and a compass lying under the neck of a lute. Music, too, was considered a mathematical art at the time. The tubes probably contained maps.

It might seem strange to us today that a display of instruments of measurement should be considered fitting attributes for a diplomat and a churchman, but it would not have seemed so at the time. Both men had been to university, where mathematics had become one of the most important academic disciplines of the Renaissance. This contrasted with the Middle Ages, when a religious explanation of the world had been considered more appropriate than the study of natural sciences, and mathematics had consequently fallen into neglect. How-

ever, as times changed, scientists began to search once again for laws of mathematics and physics which would make it possible to explain how the world functioned.

Even painters occupied themselves with the study of mathematics. In his *Instructions for Measurements taken with the Level and Compass*, Holbein's compatriot Albrecht Dürer had celebrated geometry as the true foundation of all painting. Perhaps the inclusion of these two instruments in Holbein's painting was a reference to the older artist's work.

The level is inserted between the leaves of a book, which, like the Hymnal, has been identified: *A sound instruction in all calculation for merchants, in three volumes, including useful rules and questions*. This was a textbook on the principles of calculation in business, written by Peter Apian, a university teacher at Ingolstadt, and printed in 1527. Apian begins with the fundamental operations of arithmetic and guides his reader via a series of steps to the extraction of square roots. With the aid of practical examples, he shows how silver value equivalents can be converted into gold value, or how to convert currencies. Then come the "useful questions", which are not much different from those used in schools to this day: "A messenger leaves Leipzig and takes 18 days to reach Venice; another messenger leaves Venice at exactly the same hour and takes 24 days to reach Leipzig. The question is: how many days pass before they meet?"

The globe behind Apian's book has been attributed to Johannes Schöner of Nuremberg. Holbein himself came from Augsburg, and it may be supposed that the objects from southern Germany which are exhibited in the painting were introduced by the artist rather than the patron. However, Holbein has altered Schöner's globe to suit Dinteville's wishes. This is evident from a comparison of the names on the painted ver-

sion with those on the original. They both have about a hundred names in common, but there are also 20 names which appear on Holbein's copy only. These names all have some bearing on the lives of Dinteville and the members of his family: Burgundy, Avern, or Polisy, for example.

Death concealed in a puzzle

Everything in Holbein's painting, whether persons or things, is represented more or less realistically, with one exception: the skull suspended above the floor. At first glance it is hardly identifiable. It is only recognizable as a skull when seen from the right or left edge of the painting, and only when it is viewed through a lens which alters its proportions altogether does the image become quite distinct (see comparative ill.).

Anamorphoses, or distorted images of this kind, were a well-known trick at the time. They were usually applied to portrait drawings, and were achieved by means of a ruler and length gauge, that is by the use of mathematical instruments. First, the artist would draw the contours of a normal portrait, over which he would then draw a grid of lines. On a second sheet of paper he would distort the grid, squashing it flat in one direction, and exending it in the other. He then transferred the portrait to the dimensions of the corresponding grid squares – a mathematical picture puzzle.

There is yet another skull in the painting: a very small one set in the brooch on Dinteville's beret. The double appearance of the skull cannot be put down to chance; Holbein's painting is too well thought out, its effect too precisely calculated. Their meaning may become clearer if we consult two paintings by Fra Vincenzo dalle Vacche, painted around 1520 for a church in Padua. The paintings do not contain anamorphoses, nor do they even contain figures; however, like Holbein's painting they show a number of different objects on shelves. One of the paintings, entitled *The Vanity of the Worldly Power of the Church and Laity*, shows a bishop's staff, a crown, an hourglass and a skull. The objects shown in the other painting, entitled *The Vanity of Science*, are a celestial globe, a sextant, a mathematical textbook, a sheet of music and a viola with a broken string. Holbein's lute also has a broken string. His own arrangement of instruments seems deliberately to combine the effect of the two Italian paintings. The common theme is vanity, or vanitas.

The notion of vanitas had wider connotations at the time than it does today. It meant blindness towards the most important things in life; also, the futility of human endeavour. A vain person forgets all too easily that he must die. A vain person believes that science can give him knowledge of the world. In a pamphlet in Latin in 1529, shortly before Hans Holbein executed his painting, the German writer Cornelius Agrippa complained of the "uncertainty and vanity of all art and science". Art and science, he continued, "are nothing but the laws and imaginings of human beings"; the truth, on the other hand, is "so great and free that it cannot be grasped by the musings of science, but by faith alone …"

We must conclude that Holbein's painting is not merely a double portrait. At first glance, its subject seems entirely worldly, entirely temporal: the official portrait of two young men surrounded by instruments of scientific and mathematical research. Even the composition of the painting, with its emphasis on powerful horizontals and verticals, seems arranged according to mathematical principles. Only the anamorphosis, apparently floating diagonally through the picture, contradicts

this regime of calculated rectangularity, giving the work an aura of contemplation and suggesting the presence of some hidden commentary on human affairs. After comparing the painting with Agrippa's text, or with paintings like those by Vincenzo dalle Vacche, one might conclude that its message was the vanity of art, science and high rank. In order to make such a statement, however, Holbein need not have disguised the skull. He therefore seems to be saying that study of the arts and sciences need not be vain at all. On the contrary, it may lead us to a deeper, more comprehensive appreciation of the world. Indeed, it is sometimes only by scientific means that we can make visible the presence of death behind phenomena, behind the pleasing appearance of things. That, after all, is what the painting achieves.

Only viewed through a lens which alters its proportions altogether the skull become quite distinct.

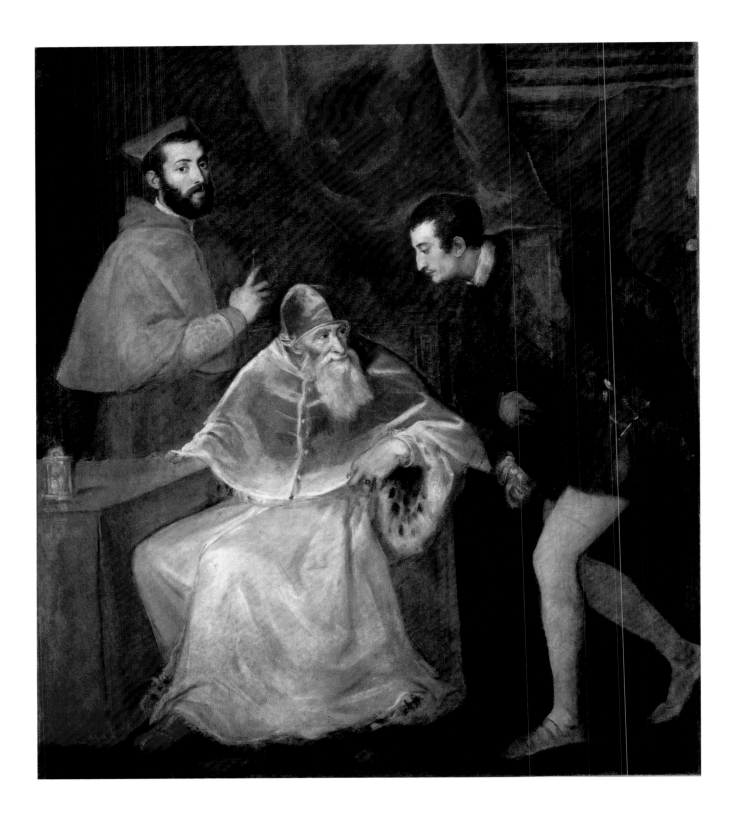

Titian (1488/1490–1576)
(real name Tiziano Vecellio)

In the end the artist, too, was cheated

Pope Paul III and His Grandsons, 1545
200 x 173 cm, Naples, Museo Nazionale di Capodimonte

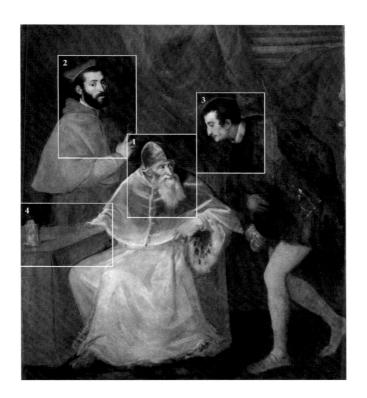

When Titian left Venice in the autumn of 1544 to travel to Rome, he was around 55 years old. It was only with reluctance that he said goodbye to his home, his workshop and Venice itself, whose lagoon made it well protected against attack.

Tiziano Vecellio was at that time regarded not only as the most famous painter in Venice, but also as the most outstanding portraitist in southern Europe. Princes in particular valued his ability to ennoble individual characteristics with ceremonial dignity. Charles V, Holy Roman Emperor, preferred Titian above all other artists when it came to having his portrait painted. He made the artist a count and a member of the imperial court, and promised him an annual pension – even if it usually wasn't paid.

The long-standing dispute over who held the highest rank in Europe – the Holy Roman Emperor or the Pope – also extended at times to the issue of who had the best artist in his employ. Charles had already been painted by Titian when Paul III, a member of the Farnese family, ascended the papal throne in 1534. The Farnese naturally wanted to engage the artist's services for themselves. They knew Titian didn't like travelling; on the other hand, it was beneath their rank to visit him in his Venice studio. So they established preliminary contact with him via a child: they sent the Pope's grandson, 12-year-old Ranuccio Farnese (his portrait today hangs in the National Gallery of Art in Washington), who was studying in nearby Padua. That was in 1542. The contact had been engineered by Cardinal Alessandro Farnese, who appears standing behind the papal throne in *Pope Paul III and His Grandsons*. He asked Titian if he would like to move to Rome and enter the full-time service of the Pope. The artist declined. In 1543 the cardinal

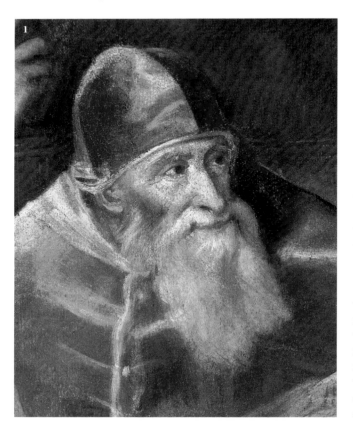

invited him to Bologna, where Paul III was meeting Emperor Charles V. It was here that Titian executed his first portrait of the Pope. This was followed by an invitation to come to Rome at least for a few months. The Venetian agreed.

Two factors prompted Titian to accept. Firstly, although already an old man by the standards of his day, he had never been to Rome or the far south and had thus never seen Italy's Classical architecture, ruins, mosaics and sculptures with his own eyes. He was a Renaissance artist who had not had the obligatory exposure to antiquity. He had been offered several invitations to work in Rome, but had never accepted – perhaps because he was afraid that the works of the great masters would throw his own ideas on art into disarray. Now, however, he felt secure enough in himself. He is said to have spent his first few weeks doing nothing but gazing in wonder at the remains of Rome's Classical culture. The second factor prompting Titian's trip to Rome was his paternal desire to help his own family. His son Pomponio had embarked on a career in the Church and was hoping to be offered a living at a monastery or church. Titian thought of the prosperous abbey of San Pietro in Colle, which bordered on some land he owned. Cardinal Farnese gave him reason to be hopeful; in Bologna, he implied that the matter had already been decided in Titian's favour.

A year later, in March 1544, Titian made enquiries on the subject but received no answer. Cardinal Alessandro Farnese was clearly aware how much the artist wanted St Peter's in Colle for his son – and used this as a sort of covert blackmail. In September 1544 the Venetian nuncio informed the cardinal in Rome that because of the benefice the artist was now prepared "to paint Your Honour's highly illustrious household in its entirety, right down to the cats."

The country which Titian crossed in autumn 1544 was fragmented and unstable, and consisted of cities and duchies which, although for the most part formally independent, in practice could only exist in alliance with a foreign power – in other words, with France or the emperor, resident in Spain. Armies of mercenaries were constantly marching through Italy; the Duke of Urbino, whom Titian visited along the way, even decided to supply the artist with a bodyguard for the last stage of his journey. In Rome, Cardinal Farnese received the artist with great ceremony and had an apartment made ready for him in the Vatican palace.

Frail and full of energy

In order to hold his own against Spain and France and their Italian allies, the spiritual head of the Catholic Church needed soldiers, money and good connections. Without them, the Pope risked being steamrollered, even on religious issues, by his powerful international neighbours. Pious monks were thus considered unsuitable for such high office – the leader of the Papal States needed to be a man with experience of diplomacy and war and someone happy to use their cunning and power.

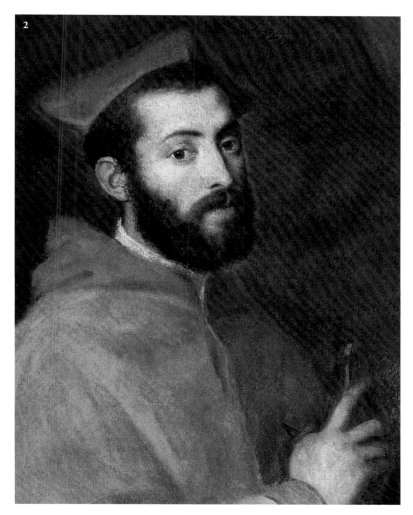

woodlands, villages, towns, bishoprics and offices. They all brought in money and were awarded as sinecures to senior members of the clergy. As a cardinal, the later Paul III owned several bishoprics, even though he had not taken the higher orders necessary to be a bishop. So he appointed someone to represent him, paid this deputy a percentage of the takings and thereby put him in a position of dependency. Dependants strengthened one's influence and power.

When the Farnese Pope had himself painted by Titian with two of his grandsons, he was 77 years old and in a tricky situation. North of the Alps, Protestantism was growing and Germany's Lutheran princes had combined their military forces into the Schmalkaldic League. Charles V needed to fight the League and imperiously demanded financial support from Paul. At the same time, however, Charles called for the convocation of an ecclesiastical council which would agree on reforms and not least remedy the deplorable state of affairs which Paul had unscrupulously exploited for his own benefit.

Quite what sort of man we are looking at in the present portrait Titian makes it difficult for us to tell. On the one hand, he shows us a shrunken old man whose shoulders are barely able to support his head upright, whose flesh is melting from his face and whose beard is unkempt. Yet on the other hand, the Pope seems full of dynamism: the fact that his body and head are pointing in different directions creates a sense of tension and movement. While his bent back and head jutting forward imply frailty, they also call to mind someone who is getting ready to pounce. The pontiff's eyes are wide open and full of energy, unlike those of most elderly people. This ambiguity, this blending of two aspects of the same person, lends Titian's pope an unsettling air.

Paul III had no scruples on that score, as his own career reveals. He came from the lower aristocracy, from a family with no useful contacts within the Curia, but he had a very attractive sister. He sent her off "to have an affair with the Pope", as Martin Luther described it, "and was made a cardinal in return".

As a cardinal, Paul III also kept a concubine, with whom he fathered three sons and a daughter. This prompted Luther, in far-off Wittenberg, to accuse him of being an "epicurean swine". In Rome, however, such behaviour was considered justified because it ensured the preservation of the family line. The latter's perpetuation – or even simply the plan to found a dynasty of rulers – provided a legitimate excuse for breaking the rule of chastity. Since his elder brother had only produced a sickly son who died young, the later Pope was obliged to make provision for the future. There is no evidence that he did so unwillingly. There is also little evidence that he applied any of the Church's precepts to himself. For men such as him, a religious career meant first and foremost the opportunity to profit from the income of the Church. The Vatican possessed countless pastorates, abbeys, landholdings,

How to stake a visible claim

Paul's son Pier Luigi produced four sons, the two eldest of whom – Alessandro and Ottavio – are included in the present portrait. They were called "nepots", an expression which meant both nephew and grandson, and which thus elegantly veiled the fact that the Pope was getting his picture painted with blood descendants he was not supposed to have.

Alessandro was appointed a cardinal at the age of 14. That was in 1534, directly after his grandfather's election as Pope. For the majority of Curia members, there was nothing improper about this: at the end of the day, a Pope needed as many votes as he could get in the college of cardinals. Paul also wanted to be able to pass on the benefices that he had assembled over the previous years to a member of his own family. Protection of

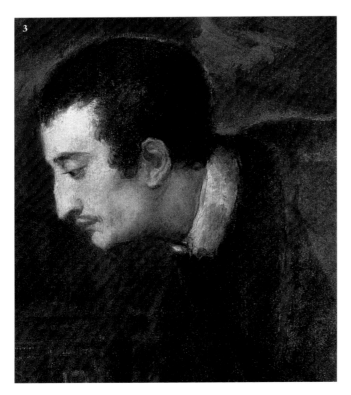

one's family, expansion of one's power and possessions – these were absolute priorities, not just amongst the Farnese, and not just in Italy. The Pope put his grandson Alessandro in charge of some 30 bishoprics.

Alessandro Farnese felt himself no more obliged to model his behaviour on the teachings of the Church than his grandfather. On several occasions he came close to giving back his cardinal's hat. He kept a mistress (and possibly several), fathered a daughter and, in his early years as papal ambassador to the French court, danced so elegantly that Queen Catherine de' Medici could still remember it 30 years later. He used the money that flowed so copiously his way to extend the Palazzo Farnese in Rome and fill it with antique treasures and contemporary works of art.

An X-ray of the canvas has revealed that Alessandro was originally positioned further to the left. It was probably he himself who persuaded Titian to move him closer to the Pope and portray him grasping the knob on the back of Paul's chair with his right hand – as a sign that he was laying claim to the papal succession. His claim failed: he attended seven conclaves but was not elected. The Counter-Reformation demanded a different sort of person to the type represented by Alessandro, his grandfather and the earlier Renaissance popes from the houses of Borgia and Medici.

Alessandro is the only one of the three figures in the painting who is looking out at the artist – and like the figure of the Pope, the look he casts is difficult to judge. Is he staring intently at the man behind the easel, or gazing more generally out into

space? Does Titian portray him as impassive, as the English art historian Harold E. Wethey believes?

Or is the young cardinal looking to see whether the elderly man at the easel will swallow a Farnese's vague promises? It was Alessandro, after all, who lured Titian to Rome with the prospect of a living for his son, and the artist establishes with him, so it seems, fleeting, meaningful yet expressionless eye contact.

No upright grandson

Titian portrays Ottavio Farnese, the 21-year-old grandson, paying reverence to the Pope in the prescribed fashion. Persons approaching the Pope had to bow three times and then kiss the papal foot. Paul's red shoe can be seen at the bottom edge of the painting and signals how low the young man in his secular dress will have to stoop.

Ottavio had a lump on his nose, and the X-ray of the painting shows that Titian had not overlooked this feature. In the finished work, the bridge of Ottavio's nose is impressively straight, almost as sharp as a knife – an improvement common in portraits, but which lends the face a smoothness which, together with the lowered eyelids, rounded back and bent knees, seems somehow suspicious. Titian was a master of body language, and in Ottavio's smoothness and the snaking pose of his body the artist portrays – without disparaging caricature – a person who is not "upright".

Nor did the young man have much incentive to behave in a straight and upright fashion. Paul III deployed his grandsons like pawns in a political game; he used Ottavio to create a family alliance with Spain, marrying him at the age of 14 to a daughter of Charles V. In 1545 the emperor needed money from the Pope for his campaign against the Protestants. The Pope gave it, but demanded in return the rights to the imperial cities of Parma and Piacenza, with which he wanted to establish a duchy for his family. He sweetened the deal by promising that Charles's son-in-law Ottavio would become duke and his own daughter duchess.

Thus far the interests of Paul III were identical to those of his grandson. The situation was complicated, however, by two members of the family who do not appear in the painting. One was Ottavio's father, Pier Luigi. He demanded the new duchy for himself. The Pope said yes, the emperor no: he let it be known that he would tolerate his son-in-law as duke, but on no account the latter's father. Ottavio's prospects of a dukedom were thus directly threatened by his own father. He plotted secretly with the emperor against his father and grandfather.

The second member of the family to question Ottavio's right to the new duchy was a younger brother. The Pope had been planning for several years to marry him to a French princess, for he wanted a family alliance not just with the emperor, but also with France, the second major power in Europe.

In order to make the marriage proposal more attractive, the Pope decided to promise the new duchy not to Ottavio, but to the future son-in-law of the French king. The split newly

emerging between Paul III and the emperor made a change of allegiance necessary. Ottavio thus saw himself cheated of his future both by his father and his brother, and beyond them by the Pope. If Titian paints him as someone whose devotion masks only anger and hatred, he is simply portraying the situation as it really was. Two years later, Ottavio finally succeeded in becoming duke – after his father was murdered by one of the emperor's henchmen.

The wrangling over the duchy took place in the first half of 1545. Titian stayed in the Vatican palace until the end of May and must therefore have been well informed about what was going on. He must have been aware, too, that the cardinal was jealous of his younger brothers: as the firstborn, the new dukedom should have been awarded to him. Only with difficulty was Paul able to restrain him from taking action himself; he mollified his grandson by assuring him that, once Pope, he would have far more power than some duke of Parma and Piacenza.

The Pope's hand is missing

Strictly speaking, the Pope's hand should be visible on the far edge of the table, but Titian has not painted it. Nor did he sketch it in prior to painting; he seems to have worked for the most part directly with the brush. Michelangelo (1475–1564), who dominated the art scene in Rome, criticized the lack of *disegno*, or design based on drawing, in the Venetian's work, but praised his colouring. In *Pope Paul III and His Grandsons* this is centred – as so often in Titian – on red, which the artist explores in all its variety and in dramatic nuances.

The Pope's right hand is not the only thing missing; other parts of the canvas, too, have been primed but then taken no further. The painting is unfinished, and why work on it should have been abandoned has been the subject of much specula-tion. There is no evidence of any quarrel between the artist and one of his subjects. A letter that Titian later wrote to the cardinal rules out any suggestion of an open disagreement.

It would be quite understandable if Titian felt let down, distrustful and full of resentment towards the Farnese, for the anticipated benefice for his son never materialized. Although, in Rome, he received his board, lodging and an honorary citizenship, as far as we know he was not paid a fee. Nor was he paid for the other paintings he executed for the Farnese during the same period. It all went towards the bill for the abbey, so to speak, for which he would have to wait a while longer.

The Italian historian Roberto Zapperi has looked closely at all the conceivable reasons why Titian should have stopped work on the portrait, and concludes that the likeliest explanation is the shift in political allegiances which took place even as the painting was in progress. When the canvas was begun in December 1544, Spain was the Pope's preferred ally; when it was abandoned in May 1545, the ally was now France. Since large-format portraits (the present work measures 200 by 173 centimetres) also served as types of official statement, Titian's work was politically no longer opportune. And so the picture vanished unframed into the Farnese cellars in Rome. Over a hundred years would pass before it was honoured with a place on the wall.

Today it hangs in the Museo Nazionale di Capodimonte in Naples and is revered as a masterpiece of a portrait which both venerates and questions its dignitaries, as a masterpiece of colour, psychology, eye and body language. Deceit and hypocrisy were considered important qualities and were highly prized by Paul III. Titian had the ability to make them transparent: in the tranquil assembly of *Pope Paul III and His Grandsons* he conceals hints of the secret war of emotions and interests. He also points to the transience of hopes and dreams – the ink bottle that stood on the table has been replaced by an hourglass.

Vain, too, were Titian's own hopes. He never got the living he had expected to earn with this painting. Instead, his son was fobbed off with a small parish – a humiliating reward for Titian's hard work in Rome and a sign of autocratic arrogance. Another quality captured for posterity by Titian's brush.

4

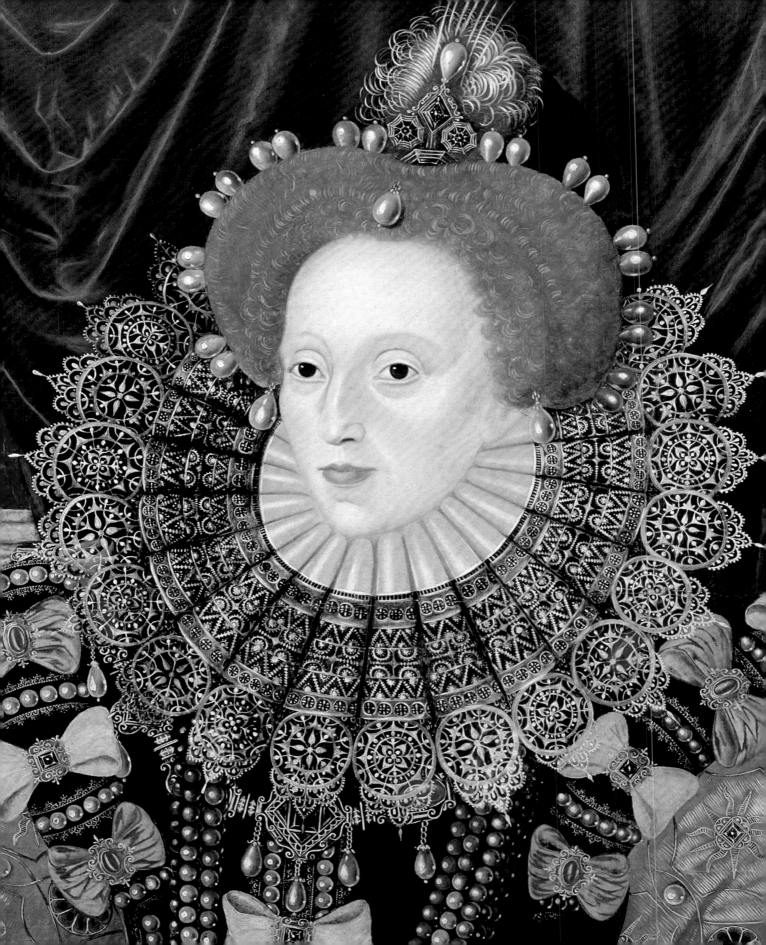

A woman thwarts Spain's pride

Armada Portrait of Elizabeth I, c. 1590
105 x 133 cm, Woburn Abbey

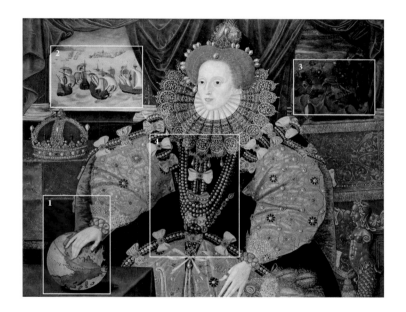

*In his portrait of Elizabeth I, executed around 1590, the English artist
George Gower presents his queen as a self-confident sovereign. He also pays tribute
to her greatest triumph: the decisive defeat which Her Majesty's navy had inflicted
upon the vast Spanish fleet in the English Channel just a few years earlier, in 1588.
The sinking of the Armada marked the beginning of England's rise to major
international power.*

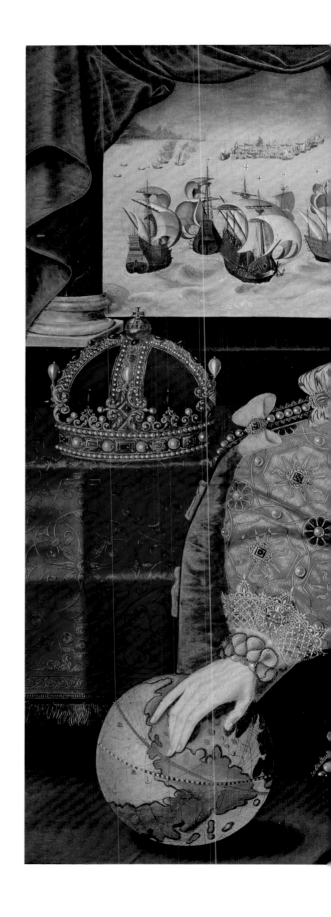

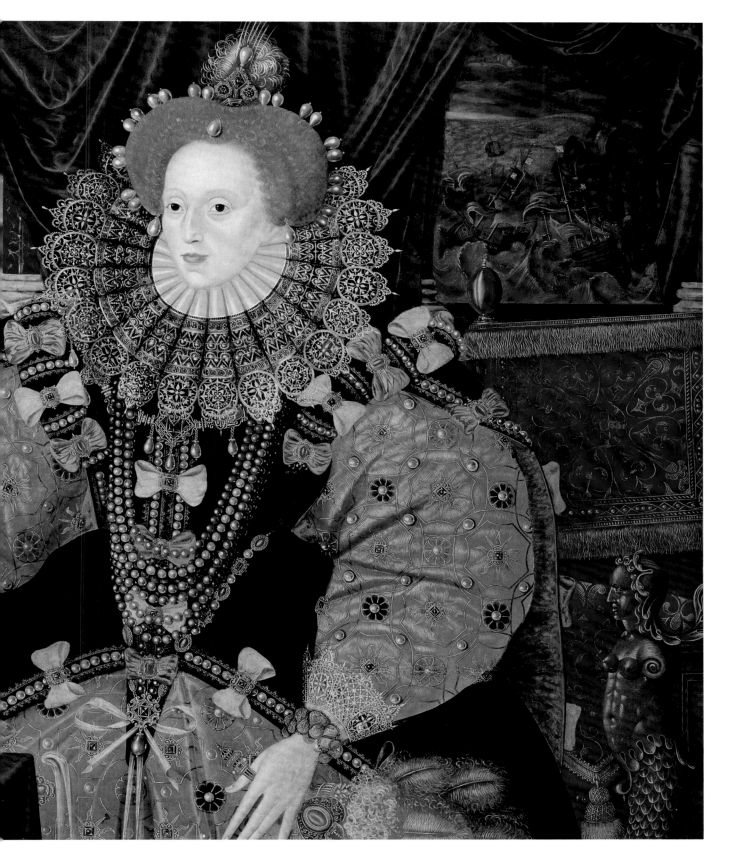

She was painted many times and had many of her portraits subsequently destroyed; it seems she felt the pictures did not show her to enough advantage. Her red hair needed to shine, proper justice had to be done to her famous pale complexion, and no shadow was to be allowed to darken her face.

When Elizabeth I sat for the present portrait, with its two background views of the sea and ships, she was about 56 years old. Her hair was false and her face plastered with a thick layer of white make-up. But the fiction of youth and beauty had to be maintained, in art as at court. The ageing queen kept young suitors and had been negotiating marriage with a French prince for decades. She enjoyed having many admirers, but had absolutely no intention of wedding any of them. At the mere age of eight she is supposed to have announced: "I will never get married!" She had good reason to make up her mind so early: that same year her stepmother was beheaded, while her own mother, Anne Boleyn, had already been executed. The cruelty displayed by her father, Henry VIII, towards his wives may thus have shaped her attitude towards marriage; it is more probable, however, that her own thirst for power left no room for a husband to reign at her side.

Portraits of this extraordinary woman were fashioned not simply to flatter her vanity, however, but also for reasons of state. Like her carefully stage-managed public appearances, these pictures were also part of a propaganda programme which had no call for realism. Thus the two scenes visible through the windows at the back took place neither at the same time nor in the same place: weeks lay between the first appearance of the Spanish Armada and its eventual defeat off the coast of England. The painting nevertheless makes sense as a glittering tribute to its sitter – it shows the most glorious event in the reign of Elizabeth I that lasted over 40 years. It was painted by George Gower (1540–1596), Serjeant Painter and one of the artists who for many years had the privilege of painting the queen.

A battle over trade and trifles

The traditional insignia of power – orb and sceptre – are missing from this picture. Instead of a sceptre, the queen holds an ornate fan of ostrich plumes in her left hand, while her right hand rests on a globe. Just as the traditional Roman orb represented the whole world, so the globe offered a modern 16th-century version of the old symbol.

In those days, globes existed only in small numbers. The first had been constructed in Nuremberg barely a hundred years earlier. George Gower has not taken pains to reproduce one of the English models exactly; he was evidently more interested in the queen's hand lying on the globe, which demonstrates in impressive fashion Elizabeth's hegemony beyond the bounds of her small island kingdom.

It was no coincidence that Gower's painted globe should also show ships, for in those days world domination meant sovereignty of the seas. When Elizabeth came to the throne in 1558, the major political and naval powers were still Spain and Portugal, both nations of explorers. In 1580 Philip II of Spain annexed neighbouring Portugal, and from then onwards, declared, "all the Americas, known and unknown" belonged to him.

Elizabeth vied with him on this score. Her subject, Francis Drake, became one the first people to sail round the world and thereby proved that the Spaniards were not the only ones capable of such a pioneering feat. Drake and other English freebooters captured Spanish galleons and diminished the profits which Philip hoped to reap from his American colonies. A small-scale war ensued. Although Elizabeth had not yet officially taken up arms against the number one

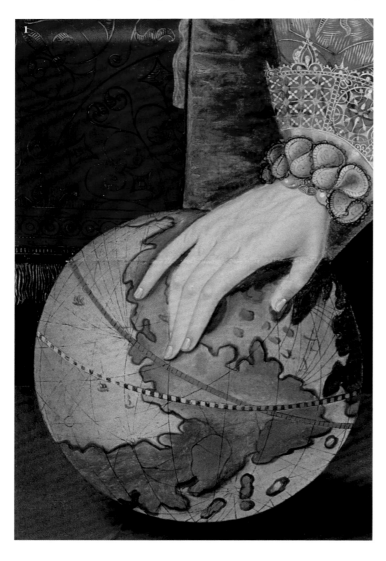

world power, she permitted her subjects to lay Spanish gold and silver at her feet.

She needed the money, because when she took up office she had inherited a mountain of debts. According to a report by the Venetian ambassador, when Elizabeth paid back the last of the money owed, she was "hailed by the people as if she were a second Messiah". But the English buccaneers embarked on their perilous voyages not just in search of booty. Philip had a monopoly on trade outside Europe, something which Elizabeth was not prepared to accept. In this she had the backing of the English merchants. The new merchant

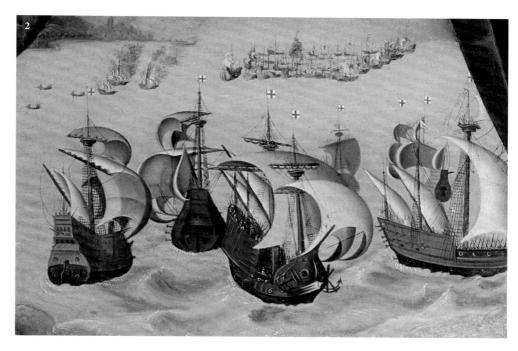

classes wanted their own slice of the international market, and Elizabeth rightly hoped that they would bring prosperity to her impoverished country.

There was yet another factor, too, in the increasingly bitter conflict with Spain. Philip II was an ardent, fanatical Catholic; Elizabeth, on the other hand, like the majority of her subjects, was a Protestant. Philip appointed himself the battlefield champion of his Church – Elizabeth had no other choice but to fight for her own.

It was a fight she did not want. As far as she was concerned, it was pointless to shed blood for one or the other variation of the faith. Her father, Henry VIII, had renounced Catholicism because he wanted to divorce the first of his many wives and pocket the possessions of the Church. His daughter, "Bloody Mary", had attempted to turn back the tide of the Reformation by torturing people and burning them at the stake. She was followed onto the throne by Elizabeth, who had thus experienced her father's abuse of religion and her sister's religious fanaticism, and who represented instead – even if she couldn't always act upon it – the law of tolerance: "There is only one Christ Jesus and one faith; the rest is a dispute about trifles."

The trick with the fireships

The view through the left-hand window shows the Spanish Armada in the background, as tight-knit as a floating fortress. They possessed more majesty than the English fleet, according to a contemporary report, but advanced only slowly even in full sail, because their hefty superstructures made the ships heavy. They approached in a crescent formation, the two cusps of the crescent at least seven miles apart.

The Armada comprised exactly 130 ships with 30,656 men on board, including over a hundred priests and monks. The voyage to England had the character of a Crusade; it was mounted against heretics. The Armada was planned as a transport fleet which would sail to Calais, pick up another 40,000 soldiers from the Spanish Netherlands, and then cross the Channel. Once on land, matters would be settled by force.

Despite adopting a new tactic, the English did not succeed in stopping the floating army on its way to Calais. The English ships were lower and faster than the Spanish "sea elephants", and although their cannons did not fire the heavy shot of their opponents, their range was longer. They therefore attempted to manoeuvre themselves close to the Spanish one behind another in a line, so that they could let off their broadsides while themselves remaining out of firing range.

To appreciate just how new this English style of warfare was, it is necessary to go back 17 years to the last great naval battle, which took place off Lepanto in the Mediterranean in 1571 and which was fought against the Turks by the Venetians and Spanish. In this confrontation, both sides used rowing galleys to board the enemies' ships and overpower their crews. Rowing galleys were not suitable for the rough seas of the Atlantic, however, and the Spaniards had to leave them behind. Boarding nevertheless remained their chief strategy, and they despised the English for not wanting to approach.

In the same view through the window, a number of the English ships are visible in the foreground, recognizable by their traditional St George's flag with its red cross on a white ground. The English fleet was headed by Lord Howard of Effingham, who was intelligent enough to call upon the

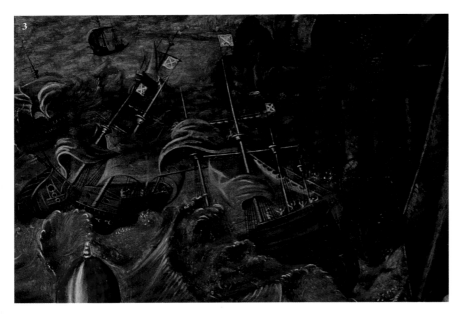

nautical experience of the former buccaneer Drake. As Sir Francis, ennobled by the queen, he held the position of vice admiral.

Gower shows the famous encounter off Calais. The English had so far failed to halt the Spaniards, and Elizabeth did not possess a standing army; the troops she had hastily rallied together were not nearly so well trained as those of Philip. The danger of England becoming a Catholic province of Spain was great. On 29 July 1588 the English set fire to several of their own ships and let them drift across to the Spanish Armada. The ships burnt out without causing any damage – but their psychological effect was enormous. The Spaniards, sailing so close together, feared nothing more than fire, and they also suspected that the English ships were concealing explosive powder kegs. Panic swept through the fleet, and the ships wildy broke formation and fled individually. A trick had blown the floating fortress apart.

Spain's Armada sinks amidst the waves

The ships seen here foundering in the waves bear the Spanish national ensign, the diagonal cross of St Andrew. Following the initial dispersal of the Armada on 29 July, the decisive naval battle took place off Gravelines. For the first time, the Spaniards emerged as clearly inferior: they lost 11 ships and counted 600 dead and 800 wounded. According to contemporary reports, when one holed Spanish ship capsized, streams of blood could be seen flowing into the sea.

The English only suffered 60 fatalities. They owed their light losses not just to their speedy ships and long-range artillery, but also to the miserable Spanish command. As in most countries in those days, it was the tradition in both England and Spain to appoint a high-ranking noble to the position of supreme command. But Philip II had thereby chosen a grandee who was prone to seasickness and who had previously only fought on land. Nor did he have a Francis Drake as his vice admiral. The second-in-command in the Spanish fleet had no reputation and no authority.

The battle off Gravelines left the Spanish demoralized. They had considered the Armada invincible and were not prepared for defeat. To avoid being shot apart by the English any further, they had to escape, and took advantage of a strong breeze which carried them north.

The Armada could no longer fulfil its instructions to transport an invasion force to England. Spanish pride, however, and a fear of Philip, meant it could not admit to failure. While the ships held their course northwards, the fleet's commanders decided to return to the English Channel "as soon as conditions permit". They all knew that would not be straightaway. Silently, the captains prepared themselves for the long and perilous voyage home, one which would take them over 1,500 miles around England, Scotland and Ireland.

The captains were instructed to sail far from the coast. But when their water and food supplies ran out, they had to seek the land, and many thereby ran aground on rocks and sandbanks. Many ships were already damaged even before they started the journey north. These problems were compounded, too, by navigational errors made by sailors who were unfamiliar with the North Sea and the North Atlantic. Altogether, the Armada lost another 59 ships on its voyage home. Only some 10,000 of over 30,000 soldiers and sailors eventually made it back to Spain.

The Armada was ultimately defeated not by the English, but by the forces of nature. The English expressed it differently. They may not have wished to claim victory for themselves, but they did not want to attribute it to Nature either; they announced instead that "this time Christ showed himself to be a Protestant."

A virgin as queen of the seas

The English could have won the day outright had their queen not been so thrifty. Her fleet only had water and provisions for two days, and the gunpowder ran out early. Under these conditions, it would have been impossible to pursue the fleeing Spaniards. In vain, Elizabeth's advisers tried to persuade her that war could only be waged successfully if sufficient means were made available, and in particular if the ships had adequate provisions.

Barely had the immediate danger of an invasion passed than the queen ordered the English fleet to disband. Unlike

Philip, Elizabeth possessed almost no ships of her own; those leased from merchants and buccaneers were given back, and the soldiers and sailors dismissed. There was no money with which to pay them off.

More men died of poverty, hunger and typhoid after the war, it is said, than fell in the battle against the Spaniards. No wonder many of the English considered their queen not just thrifty, but mean.

Faced with the magnificent outfits in which she had herself painted, and which she also donned for her public appearances, the tight rein which Elizabeth exercised over her spending seems something of a contradiction. But the lavish dresses and expensive jewellery cost her little: she had them given to her. On 1 January every year she graciously accepted clothes and jewels from her admirers and courtiers. After his circumnavigation of the globe, Francis Drake presented her with a crown of gold and precious stones which he had plundered from the Spanish. Elizabeth acquired the six strings of pearls which she is wearing in this picture from her sister Mary Stuart, at a price well below their true value.

The many bows, lace trimmings, pearls and diamonds adorning Elizabeth's dress were not merely the attributes of a vain queen, however. They also helped to lend Elizabeth the individual a symbolic stature. The various precious stones carried their own meaning. Pearls, for example – especially predominant in the present Armada portrait – come from the sea: they testify to the fact that, following the defeat of the Spaniards, Elizabeth has become the "queen of the seas". Pearls were also viewed as symbols of virginity. Like the diamonds and topaz on her dress, they are a declaration of purity. What the real state of affairs was, and how far Elizabeth actually went with her lovers, is another question, one often asked at her court and much loved by her biographers. But as the representative of her island, as a symbolic figure, she was emphatically a virgin.

For in order to assert themselves against Spain, the English urgently required a highly stylized, almost mystical figurehead. What was at stake was not money or ships, but religion. Philip had the entire ideological power apparatus of Rome behind him. Elizabeth possessed nothing comparable. She had to appear both as England's regent and the head of its Church. If the others were fighting for the Virgin Mary, the English could at least fight for their Virgin Queen.

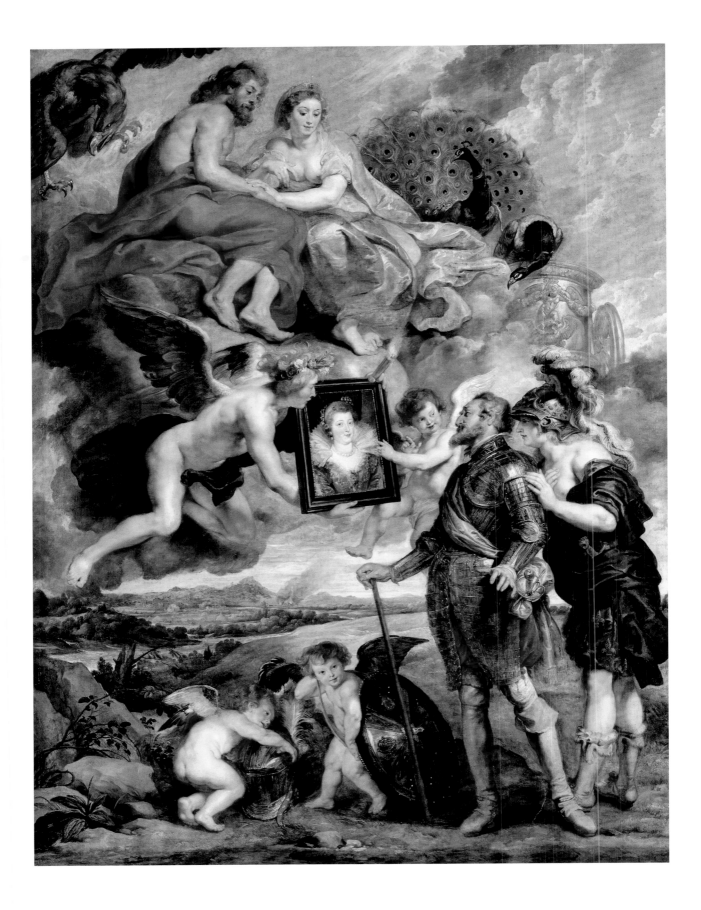

Peter Paul Rubens (1577–1640)

A royal match

Presentation of the Portrait of Marie to Henri, 1622–1625
394 x 295 cm, Paris, Museé du Louvre

The gods of marriage and of love, Hymen and Eros, have descended to the earth in order to present to the king of France a portrait of his bride. She is smiling seductively at him from out of the wooden frame. Her name is Maria de' Medici and she is from Florence. She was betrothed to Henri IV in 1600 after they had become known to each other through go-betweens and portraits. They were not to meet until two months after the wedding.

At the time she became engaged, Maria was 27, an old maid at a time when 15 was considered a suitable age for a girl to marry. Her family tree did not amount to much. The king could trace his ancestry to St Louis, whereas the Medici were parvenus; while they were descended from the once mighty banking family, the uncrowned rulers of Florence, the fact was they had never worn a crown. Still, Maria's uncle, the Grand Duke of Tuscany, was a wealthy man, and played a decisive part in bankrolling the monarchs of Europe. This uncle loved his niece, and the dowry he proposed to give with her made her (despite her unprepossessing family tree) the most desirable match in Europe. So the uncle wanted to see her on a throne. She wanted the same. It was an aim that was worth waiting to achieve.

Beside that lofty ambition, her life in the Pitti palace was fairly grim. All around her were sickness, intrigues, and murder. Her parents died in mysterious circumstances. Her uncle, who after all meant well, remarked that she "was excelled in beauty and intelligence by her sisters"; and indeed, her education was adapted to her modest talents. Henri IV's first wife knew Latin and Greek; Maria did not even speak French. But she was very religious, and knew court etiquette, though she would forget the rules of protocol when she was seized by one of her fits of rage. The Duke of Saint-Simon described her thus: "An altogether limited mind, always under the thumb of the scum of the court, bereft of any knowledge and without the slightest insight, hard, haughty, domineering". But certain of her external features pleased the taste of the time: her blonde hair, rosy complexion, and an element of the voluptuous – in the 16th and 17th centuries, a double chin was an essential mark of female beauty. Maria was majestic when she walked; fawning poets likened her to the goddess Juno, while sharp-tongued French ladies-in-waiting saw her as "the cow that bore the calf".

Gazing in admiration at the portrait of his bride, Henri IV is shown standing in shining dress armour, a white sash about his breast. White was the colour of the dynastic house. Rubens has painted him in a noble stance, all majesty, every inch a king. His country, personified as the helmeted amazon Francia in a blue dress with lilies, is looking over his shoulder with manifest interest. She is leaning trustingly on her king, who rightfully declared in a letter: "France is deeply obliged to me, for I have worked well on her behalf."

An unusual king

Henri IV was the most popular of all the French kings, and the hero of countless anecdotes. Generally they began with the king talking incognito to the ordinary people, who told him the truths that were in their hearts. It was not Henri's majesty but his simplicity, joviality, and closeness to his people that made him the stuff of legend. "Henri did not look majestic", Tallemant des Réaux noted.

When he became betrothed to Maria de' Medici, Henri was 47. He was 20 years older than his bride, and his age was

an advanced one in a time when average life expectancy was 33. His beard was already white, his teeth were falling out, he was troubled by the first twinges of gout. He was shorter than he appears in the painting, and needed steps to mount his horse.

He rarely stood in the quiet contemplation depicted in the painting, for even in advanced years he was so active a man that contemporaries were astounded and his staff were left out of breath. He would deal with the affairs of state whilst walking at a brisk pace, and it was said of him that "he went through more boots than shoes, and spent less time in bed than others at table". He divided up his time between war, hunting, sports, gaming, and women, "and was ceaselessly on the move or at his exercises". He was not normally dressed in such finery as he is in the painting; quite the contrary, a good horse meant more to him than fine clothes, and one courtier noted that "he is often to be met wearing a torn jerkin, his face … moist with sweat, his beard and hair thick with dust". Beneath his jerkin he wore ragged shirts, and "he was not fond of tidying or styling his hair, or indeed of combing it, and hated all who took pains with their hair". If the king seldom washed, that was a trait he shared with most of his contemporaries, but the stench Henri emitted apparently surpassed what was usual, for it was often referred to: "he had odorous feet and armpits," one source reports, while one mistress told him to his face that he stank "like a rotting carcase". Henri had grown accustomed to neglecting his clothing and physical hygiene in 20 years of leading the life of a soldier, almost always in the field. His friend and fellow soldier, the poet Agrippa d'Aubigné, commented: "on his skin, his many toilsome endeavours have left the dirt of poverty".

Henri grew up in the time of religious and civil wars that racked France in the second half of the 16th century. From his mother he inherited the small kingdom of Navarre on the

Spanish border, and the Protestant faith; this inheritance pre-destined him to be the leader of the Huguenots. His marriage to a sister of Charles IX, conceived as a symbol of reconciliation between the Protestants and the Catholics, led instead to the horrors of the St Bartholomew's Day massacre in 1572. Thousands of Protestants were slaughtered. Henri escaped, and from that moment on was in the field, first as the leader of the Huguenots and soon as the spokesman of all who aimed to end the civil war by compromise.

By 1589, quite unexpectedly, every heir with a closer claim to the French throne than Henri was dead; but the majority of the French were not prepared to recognize a Huguenot as their king. Now Henri was fighting for his own kingdom; but Paris defeated him. Only when he renounced his Protestant faith in 1593, declaring "Paris is worth a mass", did he secure the throne for himself. Even now Henri still had to fight for his kingdom, arduously taking it city by city (or buying it with bribes, which cost a fortune). By the end of the century he had at last attained his goal. He was the acknowledged, crowned king of France, lord of the entire land, and the sole king of France, who owed his crown not to the grace of God but to the power of his own sword. This gave him prestige and authority. His achievement as general and politician was unique, and now he stood victorious. His country, however, was in ruins, and he himself fearfully in debt and exhausted. "France and I", he remarked, "need to get our breath back at last."

The white plume

Now, with peace reigning in the land, two winged putti at the bottom of the picture are removing his warlike attributes, his shield and his white-plumed helmet. Since Ivry in 1590, when Henri had led his troops into battle against the Catholic army, that white plume had been his emblem. Before the battle, d'Aubigné (who was there) tells us, Henri told his forces: "My friends, God is on our side. Over there are His enemies and ours. Here stands your king. Attack! If you should lose your standard, rally behind my white plume – you will find it on the way to victory and honour!" Rosny, the king's companion in arms (and later, as the Duke de Sully, his minister of war and finance), was wounded and had to withdraw under a tree. He thought the battle was lost. But suddenly he saw the king, "two lengths ahead of the rest, charging like a madman into the forest of enemy cavalry lances. His people hesitated for a moment, then hastened after him, encircled him, and with him launched a fearful attack, led on by the white standard borne aloft by Pot de

Rhodes. And when he was hit by a shot between the eyes and could no longer guide his wild horse, it was only the king's white plume that led on his noblemen."

This incredible attack confounded the enemy. Panic spread, and Henri won the day. "With his own hand he killed seven of the enemy and captured a standard." From then on, the white plume stood for the king and his unusual valour. It is worth adding that the evidence suggests that at Ivry he wore the plume not on a helmet but on a plain hat, which according to the records of the Navarre treasury he had bought back in 1588 for 100 ducats. This plain hat was perhaps not so plain, though, being bejewelled with pearls and amethysts.

Now that the arms could be laid aside, Henri had the opportunity to display his statecraft, which proved as remarkable as his valour. When Henri took up the reins of government at the close of the century, the foreign enemy (Spain, summoned by the Catholics) had been pushed back over the border, but France, after almost 40 years of civil war, was in a chaotic state of marauding and robbery, disorder and disintegration. The peasantry, pillaged time and again, refused to pay their taxes. The state finances were bankrupt, the administrative and judicial sectors in a state of collapse.

With the support of able ministers (Henri chose well), the king set about the work of reconstruction. His aim was to restore royal authority, order, and prosperity in the country. Might every Frenchman have a chicken in the pot on Sundays! A revival of agriculture, trade, and industry was the goal. To attain his ends, Henri chiefly needed two things: money and time. Money could be obtained by a wealthy marriage. Time was at a premium, though, not least because of the king's

advanced years. He was under constant threat, the intended victim in a series of assassination attempts. The religious war might be over without either side having won a victory, but the passionate feelings of hatred and fanaticism that it had prompted still ruled the land.

Henri was living dangerously and he knew it. But what he really wanted was to savour life at last, "enjoy a good day", as he put it, "as recompense for all the bitterness, trouble, unpleasantness, toil, horror, and danger I have been through, from my childhood to my 50th year".

A marriage made by Eros?

In Rubens it is the gods of love and marriage, Eros and Hymen, who present to the king the portrait of his bride, Maria de' Medici; in reality it was people such as his minister of finance, Sully, who alerted him to the potential match. For the king needed not only money, he needed a legitimate heir. Henri's first marriage to the brilliant, beautiful, and highly educated Margaret of Valois, whom he was obliged to marry in youth for reasons of religious politics, remained childless. For many years he had been living in separation from Margaret. Her own brother felt compelled to lock her in a fortress because of her scandalous lifestyle. Henri wanted a divorce and offered substantial amounts if she would consent. Steps to obtain a divorce had also been taken at the papal court. Meanwhile, Henri led a bachelor life in every respect: "His majesty's usual pursuits are hunting and love", we are told. He took his lovers from every level of society. "Often", d'Aubigné writes, "his conquests had an odour of dishwater about them." Not till the closing years of the century did Henri begin to reduce the number of his adventures. At last he had found a woman who could captivate him for good. She was Gabrielle d'Estrées, known as "la belle Gabrielle". But just a few days before they were to be married, she died.

The king was in deep despair. His condition worried his friends. They counselled him to marry according to his station, "for his own peace, that of his country, and his own satisfaction". The more reckless amongst them suggested that he should first take another lover, and proposed a variety of ladies to him. Incautiously, the king opted to pursue both courses simultaneously, which was to cause him considerable trouble. The number of potential brides was far smaller than the number of possible mistresses. The Infanta of Spain was old and ugly, and Henri did not care for German princesses: "I do not like the women of those parts", he declared; "if I were to marry one of them, I should forever be thinking I had a barrel of wine lying beside me". Presently Henri was convinced that the niece of the Duke of Florence, "though from a house not at all old", was the right match. In the autumn of 1599 the king told a courtier "that there was a virtuous princess in Florence by whom he hoped shortly to have children, that he already owed her uncle more than 500,000 thalers and would be able to settle the debt in this way, and that in addition he would receive a handsome sum of money that he would be able to use for his affairs and to relieve his realm of its heavy burden of debt."

Wooing the bride consisted mainly in negotiating the size of the dowry. Initially the French court demanded a million, since Henri's debts stood at 1,174,147 gold thalers. In late December the parties agreed on a dowry of 600,000 gold thalers, of which 350,000 were to be paid out and the remaining 250,000 offset against the French crown's debts. The marriage contract was signed in Florence in April 1600.

More speedily, though with no smaller degree of haggling, the king embarked on a new affair. Just three weeks after the death of la belle Gabrielle, Henriette d'Entragues was presented to him: "She was dark-haired, saucy, agile, lively, mischievous, jolly, forever finding witty replies and bons mots that made one laugh, perverse, a wasp made to sting back to life a heart that supposed itself dead." She was also a calculating intriguer, and took immediate aim at the crown, putting pressure on the king by denying him her favours. Once he was quite beside himself with lust, she seduced him into making a formal promise of marriage. Sully, incensed and forgetting the deference he owed his king, tore up the document; but it was drawn up afresh. In it, Henri promised "to marry Henriette if she becomes pregnant within six months and is delivered of a son". It was only then, in mid-October, that she slept with him.

Six months later, when the Medici marriage contract was signed in Florence, the king, who had meanwhile bestowed his favours on at least three other ladies, asked Henriette to give him back his pledge, as if this were the most natural demand in the world. She refused. Henriette was pregnant. The king was in an embarrassing predicament, but chance came to his rescue: Henriette, frightened by lightning, had a miscarriage, leaving the relieved Henri to go to meet his bride Maria. In July he wrote to her: "I urge you to look after your health, so that when you arrive we may make a fine child who sparks laughter

in our friends and makes our enemies weep." But even on the journey to Lyons, where Henri was to meet Maria, Henriette accompanied the king. Mockingly she enquired when his "fat bag of money" was due to arrive. To which the king retorted: "As soon as I have chased all the whores out of my court." But in fact he did no such thing.

A hall of fame for an infamous life

Enthroned upon clouds, the supreme god, Jupiter, and his spouse Juno, are gazing graciously down at the bridal couple. Behind Jupiter is his emblem, the eagle, while Juno's peacock carriage waits beside her. Mythology contains many a tale of marital strife and jealous scenes that raged between these two deities. A similar lack of harmony awaited Henri and Maria in their ten years of marriage. Sully reports that he "never saw them together for a week on end without a quarrel". The differences between the lethargic and limited Maria and the active, highly intelligent king were too great. But the principal cause of their rows was Henri's continuing affairs. His father had been denounced by Calvin as "in thrall to Venus", and Henri was a chip off the old block: in the last years of his life he went through women at an almost pathological rate. As well as his countless affairs (the last being a 13-year-old maid of honour), he thought nothing of keeping Henriette at court, despite the fact that she was involved in several conspiracies against him and was forever threatening to have his marriage to Maria declared null and void. Henri had children by both Maria and Henriette at the same time, and had his bastards from every conceivable bed brought up together. The Tuscan ambassador exclaimed: "Truly, has anything ever been seen that was more like a brothel than this court?" Maria, needless to say, was jealous. But jealousy, in the view of the Venetian ambassador, was "really very bourgeois". Queens did not display such feelings.

Still, Maria did fulfil two expectations. She brought with her the money Henri craved, which enabled him to rebuild his country and equip his fleet for a campaign against Spain, which he hoped would finally crush Habsburg aims to major power status. And she dutifully bore him six children in eight years. The heir to the throne was just nine years old when Henri was assassinated in 1610.

While her son was not yet of age, Maria ruled France. Her political inability and her stupidity made her easy prey to Florentine intriguers whose only thought was of enriching themselves. Without a fight she conceded the dominant role in European power politics to the Habsburgs; aimlessly she squandered the state's resources; she was weak when confronting rebellious nobles. Henri's achievement crumbled in her hands. In 1617 Maria was removed from power by her son, Louis XIII; her confidants were eliminated and she herself imprisoned. She escaped in the most adventurous of manners, down a rope ladder, and without hesitating joined the rebel nobles in their fight against the king.

Presently, however, Maria's protégé, the young Cardinal Richelieu, managed to mediate between mother and son. To celebrate their reconciliation, Maria was permitted to commission a series of 24 monumental paintings from the Flemish painter Rubens, immortalizing the various episodes in her life – a hall of fame for herself. This was a task of some delicacy, and called for extreme wariness and consideration in the artist. But this was nothing new to Rubens, a man of the world with diplomatic experience. His style and his angle of perception coincided perfectly with the requirements of the court.

And so he transformed this life of failure, intrigue, and pettiness into something exalted and exemplary. He placed the protagonists in the company of the gods, casting a noble light upon their squalid reality with the help of allegory and myth. The completion of this mammoth cycle, in 1625, was the last climax in Maria's life. Witless as ever, she fell out with the king's counsellor, Richelieu, who had her imprisoned anew. A second time the old woman escaped, this time fleeing abroad. Unwelcome wherever she went, she travelled on, embittered and forever scheming against France, till in 1642 she died in Cologne, alone and far from Rubens's pictures, from those works that have magnified her name down through the ages.

Diego Velázquez (1599–1660)
(full name Diego Rodríguez de Silva y Velázquez)

The victor honours a defeated enemy

The Surrender of Breda (Las Lanzas), c. 1634/1635
307 x 367 cm, Madrid, Museo Nacional del Prado

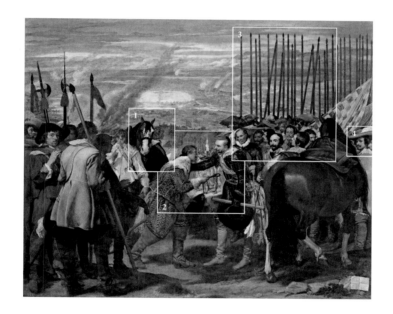

The Catholic Spaniards had besieged Protestant Breda for 12 months before hunger forced the commander of the fortress to submit. The artist, commissioned to celebrate Spanish victory, was faced with a problem: few Spanish soldiers had been present at Breda and nothing particularly heroic had taken place. Velázquez chose a different subject: the noble attitude exhibited by general and commander.

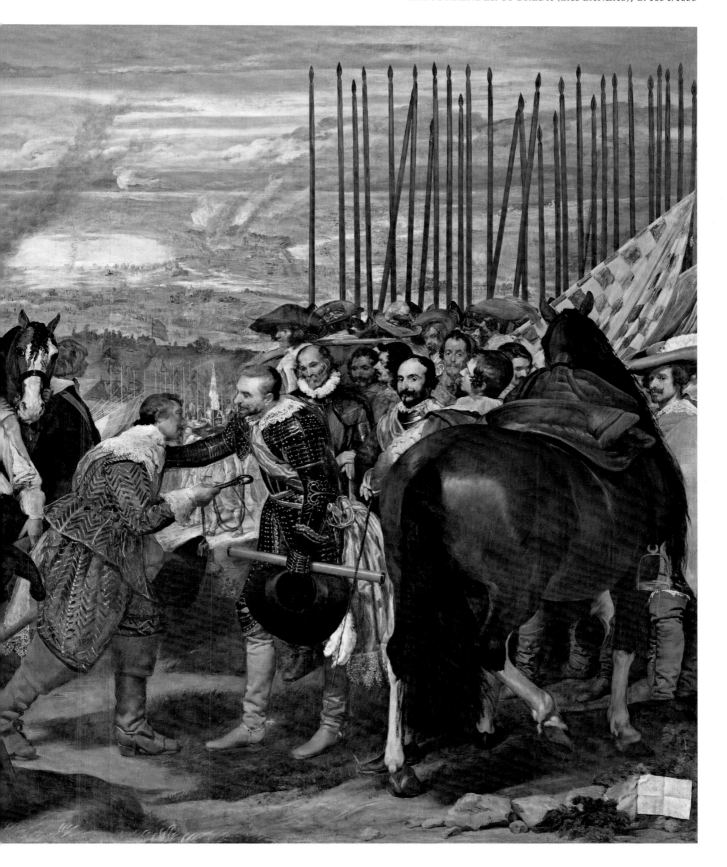

The date: 5 June 1625. The time: ten o'clock in the morning. The commander of the Dutch fortress of Breda hands over the key of the town to his victorious Spanish counterpart.

Spain, at the time, was the "land on which the sun never set", with dominions in America, Italy and Burgundy; it comprised the whole Iberian peninsula, including Portugal. The Netherlands, too, were a part of the Spanish Empire; but only the Catholic south remained loyal to the king in Madrid, while the Protestant northern provinces rebelled. Breda lay on the border between the north and the south. For the Spanish, it was the "stronghold of Flanders" and a "sanctuary for traitors".

The war in the Netherlands had begun 60 years earlier; at the time, Philip II had sent the Duke of Alba to secure Spanish rule. Philip III then agreed to a truce. Sixteen-year-old Philip IV, mounting the throne in 1621, sought a decisive blow in the north. His commander in chief in the Netherlands, Ambrogio Spinola, had taken Jülich. But the king wanted Breda, too. His council of war advised against the move: a siege would be costly and bring little military advantage. But the ruler, now 19 years of age, sent Spinola a note with the words: "Take Breda!" Signed: "I, the King."

Spinola besieged the fortress town for 12 months. He repulsed two relief offensives mounted by the Netherlandish side. His own army meanwhile was decimated by epidemics.

Then he received intelligence from a number of intercepted letters that the besieged were suffering from starvation; they were on the point of surrender. The capitulation was formally signed on 2 June 1625. The garrison withdrew on 5 June. News of the surrender took ten days to reach Madrid; Te Deums were sung in every church.

Spinola offered the Dutch extraordinarily honourable terms of surrender: the commander and all officers and soldiers "shall, as befits brave men of war, withdraw fully armed in an orderly fashion; the infantry shall leave with flags flying to the beat of drums, their muskets charged and slow match lit (that is, ready to do battle); the cavalry, with cornets flying, shall leave to the sound of trumpets, armed and mounted as if to start a campaign". The conditions also permitted the commander of the garrison to take his furniture, and granted an amnesty to the inhabitants of the town. On 5 June Spinola met his adversary before the town walls. He "greeted and embraced the commandant of Nassau warmly and, with words more amicable still, praised the bravery and steadfastness of the defence". Thus the description of the event in a report published in Antwerp in 1629.

It was the form of the surrender which evoked the enthusiasm of the Spanish response. This is illustrated both in a play written by Calderón and in the painting by Velázquez. Calderón de la Barca was 25 years old at the time. His play, entitled *The Siege of Breda* was first performed in 1625, the year of the surrender. The poet celebrates the meeting of the two commanders in long, elegant dialogues: "The bravery of the vanquished honours the victor," says Spinola's stage persona. As for Velázquez, his chosen subject is not the depiction of Spanish troops as they repel an enemy relief force or enter the besieged town; nor does he paint Spinola's horse shot from under him; in fact, he does not include the fortress of Breda in his composition at all (it lies to the left of the depicted scene).

Instead, Velázquez shows an encounter between two human beings: one on bended knee, the other, in a consolatory gesture, resting his hand on the shoulder of the first. An utterly unwarlike scene amidst the weaponry and dogs of war.

War: a chessboard with soldiers

Breda was not taken by bravery, but by stealth and stamina. The days of the Gueux, when the Dutch had terrorized the Spanish army with cunning guerrilla-style tactics, were over. Now was the hour of the war of position, in which the fighting was more like a game of chess: units of troops shunted back and forth, each party attemping to force his opponent into checkmate.

The Dutch master of scientific warfare was Maurice of Orange. Knowing how exposed to attack Breda was, he had had the town turned into a model fortress. The commander of the fortress was the 66-year-old Justin of Nassau; his opponent was not a Spaniard, but a Genoese: Ambrogio Spinola. Spinola was an ascetic: cool-headed, self-denying, always ready for ac-

tion. Khevenhüller, the Austrian ambassador to Madrid, wrote: "He (Spinola) frequently went into seclusion with the engineer Giovanni de' Medici for many hours to work out what the siege would cost, how long it would last, what they would need to sustain the alertness of the army, and to prepare for every eventuality…"

Spinola was forced to wage war on two fronts: one against the army stationed in the garrison of Breda, the other against relief forces from without. For protection, he built two ramparts, or defensive mounds, almost entirely surrounding the town. Velázquez has painted them in the background. It took five hours to walk this double ring of fortifications. The Spanish army was encamped between the two walls. Spinola had some of the meadows flooded in order to provide further protection for his army. This is suggested in the painting, too. The boys beside the horse are probably cadets, in training at the military academy in Breda. It is said that young Protestants from all over Europe were sent there.

As predicted by the council of war, the Spanish investment of enormous sums of money and gold in the campaign, as well as the commitment of their army to the siege, did not ultimately decide the war in their favour.

However, military and financial questions were by no means the sole criteria in the eyes of 16th- and 17th-century Spanish monarchs; for they saw themselves primarily as warriors of the Church. The provinces of the Iberian peninsula had been united by the crusade to expel the forces of Islam. This had a lasting effect: rather than expelling infidels, the new crusade was directed against the Protestants. What was worse, the Protestants had managed to gain a foothold on Spanish soil, for the Dutch provinces had fallen to Spain by inheritance. No king worth his salt could tolerate them. Freedom of religion? Quite unthinkable! Any monarch in Madrid who remained loyal to his heritage was impelled by his religion and Spanish tradition to take up the sword against those who had apostatized from the Catholic faith. Whether or not the struggle was ultimately successful was of secondary importance.

Sosiego: a quality befitting the victor

Spinola had been born into a Genoese family of merchants and raised to the rank of Marqués de los Balbases by the Spanish king. This was a great honour, probably conferred upon him in gratitude for military services, and possibly also because Spinola himself embodied a virtue of which the Spanish thought most highly: *sosiego*.

One way of translating *sosiego* is "equanimity". It is no accident, for example, that Spinola was reported to have borne the trials of the siege with "serene equanimity". The quality of *sosiego* is therefore reminiscent of the philosophy of the ancient Stoics, according to which the world was imbued with an elemental, divine force. Everything that happened in the world was preordained and therefore right. A human being was to bear his destiny without protest: to accept it with equanimity, in other words.

Calderón makes use of this idea in his Breda drama. He makes Justin of Nassau speak at the surrender about the pain of the moment, but also of defeat as the will of Destiny: a force which can crush even the proudest state into the dust.

The Spanish word *sosiego*, however, does not only mean equanimity; it also suggests a sense of superiority. The Spanish considered themselves the most powerful nation in Europe: they had driven the Moors from the Spanish peninsula, thereby expelling Islam from Europe; they had "Christianized" America; they were the rulers of a large part of the European continent.

Their glorious history and (supposedly) vast power thus made it relatively easy for them – and their

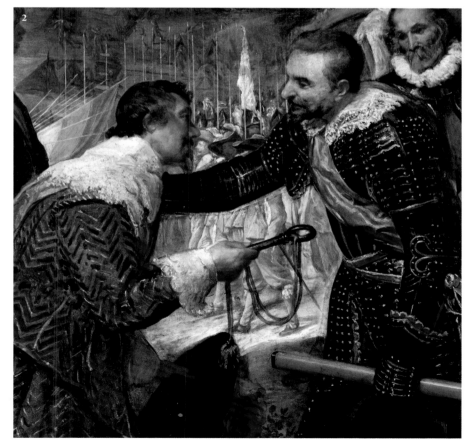

bols of military strength. By the time of the siege of Breda, firearms had not yet come into their own. The Dutch used short spears. The Spanish infantry approached their enemy in tight, oblong formations of several hundred pikemen. While Calderón compared the pike formations with fields of corn, one French writer described them as moving towers, capable of immediately closing up holes in their own brickwork. The mere sight of such formations must have been enough to fill the enemies' hearts with dread.

Under Philip II, the grandfather of the king on the throne in 1625, Spanish soldiers had been famous for their discipline. Their perfectly vertical pikes held up in parallel had come to symbolize military order. Velázquez did not wish to paint a display of military prowess, however. Not all of the pikes are held up vertically. The heyday of Spanish discipline was over. By the time Velázquez came to paint this picture, the only Spanish volunteers were adventurers and criminals on the run. The Spanish ranks were largely com-

generals – to display magnanimity towards an adversary. After all, the latter could not ultimately damage Spain, which was great, and was fighting for the one true, Christian religion. The state was thus acting in full accordance with "divine force".

The Spanish no longer wanted to fight

In Spain, the painting was often referred to quite simply as *Las Lanzas* – almost a quarter of the canvas is dominated by lances, or pikes, which, for many centuries, had been the sym-

posed of foreign mercenaries who changed sides regularly, were paid little, and placed all hope in booty. When a military campaign came to an end, they were dismissed, forming bands of marauders who were the scourge of the rural population. During the Thirty Years' War (1618–1648), central Europe was full of unemployed mercenaries looking for someone to lead them. Those in service were frequently worse off still. In 1629, four years after the triumphant victory at Breda, a letter from Flanders arrived at the Spanish court: "The soldiers are starv-

ing to death," it reads, "and go half-naked from door to door begging for alms. We have reached the end of our tether."[2]

Velázquez's pikemen are almost faceless. Unlike the officers observing the ceremony, they have kept on their hats. Perhaps they are watching the withdrawal of the Dutch garrison in the background. They would probably feel some bitterness at the fact that their hopes of plunder had been foiled by a gesture of *sosiego* for which they would not feel the slightest sympathy. *Sosiego* had nothing to do with the reality of their lives or needs.

Spinola's officers were Italians, Germans and perhaps even Flemings, but there was hardly a Spaniard amongst them. The Spanish noblemen no longer wanted to fight. They rejoiced at their monarch's military success, organized sumptous feasts for his and their own pleasure, but they no longer went to war themselves. That was a thing of the past. Special taxes imposed by the king on those who refused to take the field had no effect; the nobles preferred to pay up and stay at home, where at least they could enjoy life. In their minds Spain was still the greatest and most powerful empire on earth; merely to be a subject of the empire was enough to relieve them of all further responsibility. If they accepted a post at all, it was as governor of a South American colony, for those who returned from such posts were rich. In Europe itself, there was little gain to be made.

With the king's commission to paint the siege nine or ten years after the victory at Breda, Velázquez was instantly plunged into a quandary. There had not been a spectacular battle worth commemorating; nor had the Spanish regiments excelled. The soldiers' main battles had been fought against hunger, cold and illness. Not even the commander had been born in Spain, let alone most of his generals, and Spinola had evolved his strategy with the aid of Italian experts. What was left? There was *sosiego* – a form of composure so highly thought of in Spain that it was assumed to be archetypally Spanish. In fact, it had very little to do with the reality of the siege campaign.

Portrait of a self-confident artist

The soldier furthest right in the painting resembles the artist himself; many art historians take this figure to be a self-portrait. Velázquez was not present at the surrender of Breda. The panoramic military landscape was probably executed after an engraving by Jacques Callot. He had got to know Spinola during travels to Italy, but was unacquainted with Justin of Nassau. The Dutch commander probably looked older at 66 than he does in the painting.

Velázquez painted the "surrender" for the king's new residence in 1634 or 1635, nine or ten years after the historical event itself took place. One of the main rooms of the new palace was the Salón de Reinos, the Salon of Kingdoms. This contained a series of 12 large paintings celebrating the military triumphs of Spain in the reign of Philip IV. Spain's greatest artists competed,

and the triumphal series attained mythical heights in a depiction of the famous twelve tasks of Hercules, the muscle-bound son of Zeus, by Francisco de Zurbarán (1598–1664).

What a contrast! A king who is unable to pay his soldiers – lack of money had meanwhile led to military disaster and death for Spinola in Italy, too – builds a residential palace with a hall devoted to his own fame, while his realm, incapable of defending itself, falls into economic wrack and ruin. The contrast was quite typical for Spain at the time: economic and political decline on the one hand, flowering of the arts on the other, with Madrid itself the cultural centre of Europe. Velázquez, Murillo and Zurbarán were all painting here during this period, as was an important representative of the previous generation: El Greco. Literature and the theatre were dominated by equally important figures such as Lope de Vega, Calderón de la Barca, Tirso de Molina and Miguel de Cervantes.

The power of a literary text is sometimes illustrated by the way fictional characters leave the written page and, like Don Juan or Don Quixote, take on a popular life of their own. Both figures originate from this period; Cervantes's *Don Quixote* was published between 1605 and 1615, while Tirso de Molina's *Don Juan* was first performed in about 1624. Furthermore, both figures are very much the products of this period in Spanish history. Don Juan is a noble who rejects all social convention and duty, devoting his life to pleasure and the seduction of beautiful women: a figure who would never have taken to the field in defence of Catholic Spain. Don Quixote is a dreamer whose head is full of old-fashioned Spanish chivalry; blind to realities, he takes up the fight against windmills.

Finally, both figures share an important quality with General Spinola, as painted by Velázquez; each, in his own way, demonstrates *sosiego*; each reveals that contempt for the real world which forms an essential component of *sosiego*. Don Quixote's failures to defend the old, chivalric values are borne with equanimity; Don Juan generously invites the stony-faced harbinger of his own death to eat at his table; he descends to hell without remorse. Spinola, meanwhile, comforts his adversary as if he were a friend, allowing his enemies to hold on to weapons which they will continue to use against Spain.

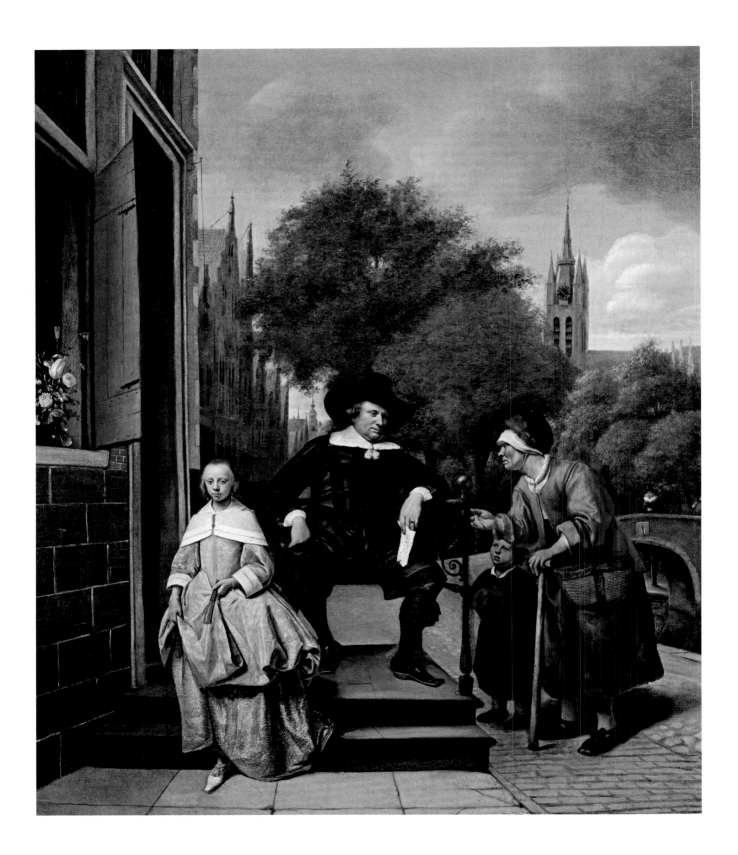

Jan Steen (1626–1679)
(full name Jan Havicksz. Steen)

A rich man sitting in the street

The Burgomaster of Delft and his Daughter, 1655
106 x 96 cm, Amsterdam, Rijksmuseum

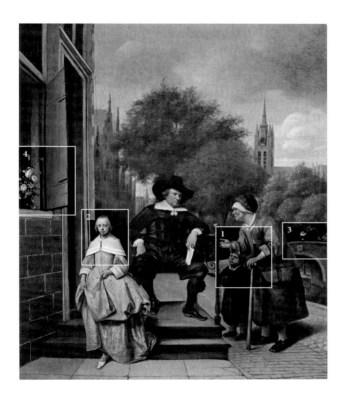

A man is sitting in the street. Or rather, he is sitting on the stepped threshold of his house, and thus at a place at once public and private. Not only this raised entry before his front door but also the paved area in front of the house is on his own land. Beside the paved strip is the brick public footway, on which an old woman and a boy are standing. Further to the right is the cobbled street intended for horses, carriages, wagons, and so forth.

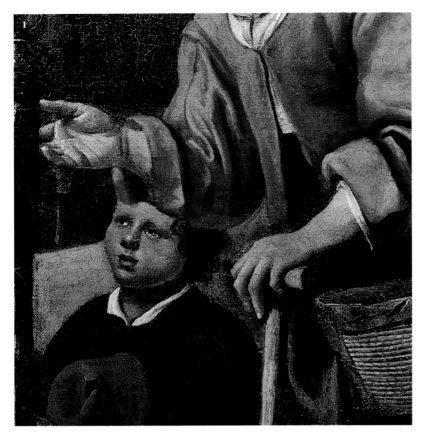

During the wars of liberation, the Dutch had made the Princes of Orange their stadtholder, but in times of peace they were too powerful for the people's liking, and in 1651 the office of stadtholder was rescinded. Henceforth, it was the patrician burghers who ruled. The man we see sitting with such self-assurance had thus been living for seven years in a newly sovereign state. And for four years it had not been ruled by the house of Orange any more but by men of his own class. The artist has portrayed him on an afternoon in late summer; by the church clock it is ten to five.

The registration of the poor

Steen's painting was made in the heyday of bourgeois culture in the Netherlands. One of the pillars of that culture was its strong civic sense. The government in The Hague was responsible for foreign policy and defence only; all other matters were for the provinces or cities to decide. The indigent lay in the jurisdiction of the cities, as did the administration of justice. There was no written penal code, and every town decided these matters at its own discretion, though invariably with rigour. Guilty parties were beheaded or hanged, drowned, or burnt alive; a hand was amputated; if the offence was less serious, the guilty party's shoulder was branded with a red hot iron. Executions were always held in public, as an entertainment but also a deterrent. Begging was subject to penalties.

A clear distinction was made between the poor of a municipality and beggars from without. The municipal poor were registered and had a licence permitting them to beg for alms. Their numbers included the sick, orphans, and old people unable to work, such as the woman in the painting, supporting herself on her stick and holding out a beseeching hand. The scrap of paper the affluent burgher is holding may be her licence. Steen does not portray this man as one who would spontaneously open his purse, or call back his daughter to fetch bread from the house and put it in the old woman's basket. This man is thinking it over, holding the licence in his hand as he ponders what is to be done. Such deliberation was considered a civic virtue and duty, since unreflecting charity might benefit frauds, especially those from elsewhere.

Every town was on its guard against itinerant tramps. They were strangers in the tightly woven fabric of a town and thus were invariably met with suspicion; they had no fixed abode to which a magistrate might have sent them back. They might be discharged mercenaries, landless peasants, workers from industries that had gone out of business, gypsies, or criminals fleeing justice. Since they could not always be turned away at the city gates, they would be given a permit to stay for a

This raised threshold, with a railing and a seat, known as a *stoep*, was often found in the Netherlands, and probably served as a place to hold conversations. Of course one might talk to passers-by from the window, where the flowers are, but it was easier without an intervening wall and on the same level. Furthermore, the seat conferred a certain dignity and placed the owner of the property on show. For someone who held public office, conversations held here could be of importance. For a long time, historians identified the man in this painting as the lord mayor of Delft, but for this there is no evidence. All we know of him is what we see. One of the things we know is that the location where he had himself portrayed is the west bank of the canal known as Oude Delft. In the background is the Oude Kerk, and to the left the twin gables of the Delflands Huis. Maps of the town show that residences on the canal-side were very narrow, and built close against each other, and extended a long way back from the street. Behind the houses were equally narrow gardens, running as far as the next canal.

Jan Steen painted this unknown man in 1655. At that time the town of Delft had a population of about 25,000 and was in the provinces of the Netherlands, which had thrown off Spanish rule after a protracted struggle. The Treaty of Westphalia (1648) had recognized Dutch independence. What remained contentious, however, was the form of the government.

limited time, perhaps three days, perhaps a month, and if at the end of this period they had not found work they had to leave the city, or the municipal officers would set their dogs on them.

The magistrates and burghers took an entirely different attitude to the poor of their own municipality. They provided them with food and shelter (in former Catholic monasteries, for instance). Thus where the Sint Agatha Klooster had been (the tower can be seen over the shoulder of the seated burgher), the Oude Vrouwen Charitaathuis was built, an almshouse for old women. It may be that this old woman lived there, or that the seated burgher held honorary office there.

Despite the much-vaunted Dutch civic sense, provision for the needy was repeatedly the subject of municipal dispute. Before independence from Spain, charity had been the province of the Catholic church. In 1572, the Delft council expropriated the church there, and took over all its charitable duties. The strongest religious institution in the sequel was the Reformed (Calvinist) Church. It attempted to define social responsibilities as its own domain, while at the same time lending support to the house of Orange, which had just been ousted from power by the government representing the burghers.

So if a man chose to be painted in 1655, in a place outside the church, pondering an act of charity, this might be interpreted as a statement: against the house of Orange, against a church that arrogated social responsibilities to itself, and for the rule of the burgher.

A daughter dressed in the court style

The burgher is sitting at his ease. His left arm is resting on the railing, his right is on his thigh. Both are supporting him and thus easing his upright posture; but they also tell us something about the man. He has not the palm but the back of his hand on his thigh, which has the effect of bringing the elbow forward and so making the sitter appear broader, of more substance. The left, relaxed arm sends a message of potential goodwill and concern; the right signals that this is not a man to be trifled with.

Jan Steen was amongst those Netherlandish painters who discovered everyday life, and, with it, everyday gestures. He became a master of body language. In his paintings, even legs and feet talk. With his knees apart, this man again seems more substantial, while the position of his feet seems to be asserting his ownership of this plot. The right foot, below the angled elbow, is somewhat withdrawn, which may be either playful or suggestive of readiness to leap to attack or defence. It is not the posture of a scholar who spends his time at a writing desk; it is far more that of a mounted military commander.

The impression made by his daughter is quite different. She is holding the hand with the fan in front of her, and with her other hand she is raising her overskirts in the manner she has presumably been taught by her dancing instructor that is appropriate when descending steps. At the time, good (i.e. courtly)

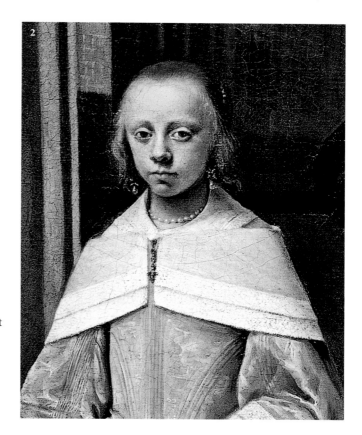

deportment required that the feet be kept close together and the arms flush along the sides, without any ostentatious or extravagant posturing.

Requirements such as these were laid down in etiquette books. Erasmus of Rotterdam, in his treatise on education published in 1532, explicitly disapproves of placing the hands on the hips whilst sitting or standing; such a position might be permissible in a man of arms, but in others would be undignified. In *Il Galateo* (1558), Giovanni della Casa likens those who strut about with their hands on their hips to peacocks. And in 1644 John Bulwer declared the posture expressive of pride and boastfulness, and unbecoming in a gentleman.

This burgher of Delft was evidently no more troubled by such considerations than many of his contemporaries were. If pictures are to be believed, this attitude of self-confidence was highly popular. It can be seen in the groom in wedding scenes, and on many group portraits, such as Rembrandt's *The Night Watch* of 1642, in which both the showily clad lieutenant and the standard-bearer have a hand on their hip, lending to a peaceable scene of departure an air of swagger and aggression.

What the writers of etiquette books spurned was acceptable to Dutchmen; indeed, they may have adopted behaviour unacceptable in court circles as a form of provocation. Or they may have intended to demonstrate their own strength: the burghers' new self-esteem established its own repertoire of gestures. But

as the century wore on, it was abandoned again, and the well-to-do took their bearings from aristocratic circles once more: the prim and proper daughter is showing her splay-legged father how those of her generation propose to conduct themselves.

Looking back to the past

Jan Steen liked to tell stories in his paintings: of brawls in taverns, of twelfth-night festivities, of weddings and family outings. There is always something happening between his personae, and the father and daughter in this double portrait are no exception. The story emerges from the presence of the impoverished woman and the boy. The father is pondering what he will do; his daughter seems indifferent, self-absorbed, in a world that is all costly garments and descending steps with style.

On the bridge in the background Steen has placed two men. One, whom we can barely see, is probably a farmer, carrying a sack to the nearby market. The other is a burgher dressed in the fashion of yesteryear: his hat is taller than was usual in 1655, he is wearing a stiff ruff rather than the soft collar of the principal character in the foreground, and the cut of his beard is no longer much seen. This elderly gentleman is watching the scene in the foreground. With his black-and-white attire, he looks like some remote double of the foreground burgher; the quality of the gaze suggests some relationship. The artist offers no explanation, but with the gentleman on the bridge he has introduced the past into his painting, a brief look back in a picture that takes pride in the present.

Some years earlier, the bridge over the Oude Delft had been a flat, wooden construction. The arched stone bridge betokens progress and prosperity. The crest is that of the city of Delft. The Delflands Huis, the twin-gabled building seen to the left, was the seat of the office of public works, transport, and waterways. This was one of the most important of public authorities, for flat Holland was criss-crossed by a network of rivers and

canals, and they constituted a major pillar of its prosperity. Neither France nor England had anything approaching so good a system of waterways, and Germany, Spain, and Italy lagged far behind. Canal transport was slower than road transport, but a horse could move 50 times the load by water. Travellers preferred gliding down the waters in the comfort of their cabins to bumpy coach rides on unsurfaced roads. All the towns of the Netherlands were linked to the seaports by the waterways, and goods arriving at the coast could thus easily be moved inland.

The Netherlands not only had the best canal system, they also had the largest of all European fleets. Their most powerful rival was England. A naval war between the two countries, from 1652 to 1654, ended in disaster for Delft: in 1654 the powder depot exploded, destroying a large portion of the city. This was the year before Jan Steen painted his burgher.

Steen himself experienced hardship during the war. Hostilities crippled trade, much reducing the chances that ships bound for America, Asia, or the Baltic would make the return voyage safely. There could be no more thought of processing English wool. The demand for faience ware, a speciality of the Delft porcelain manufactories, fell. And so, too, of course, did the demand for art. Steen had moved to Delft because his father had taken a lease on a brewery for him there. The artist could not support a family on paintings, and he had learnt the brewer's trade in his youth. Like the burgher's house, the brewery was on Oude Delft, though on the opposite bank. Steen was unable to make a success of beer in Delft.

From there he moved with his family to Leiden, later to Warmond, thence to Haarlem, and then back again to the city of his birth, Leiden, where he opened an inn. What he observed there, the revelling overconsumption of beer and tobacco, the brawls, the card-playing, is all to be seen in his paintings. To what extent he himself participated is a moot point. The fact that Steen's paintings are to be found in museums all around Europe demonstrates that he was a prolific artist; and yet he left his widow only an inn up to the hilt in debt. He died in 1679 at the age of 53.

Flowers in memory of the dead

Painters generally positioned what was of importance in the centre of a picture. Details on the edges were not expected to excite undue attention. Steen, however, broke this age-old rule with his flowers. They are more colourful than any other part of the composition, and they are so detailed and so carefully nuanced that we might be standing right before them and not (as the structure of the work implies) a few metres away.

The flowers are isolated. They are like a picture within the picture. Like a still life. This type of painting enjoyed great popularity in 17th-century Holland, and indeed the very term came into being at this period: *still-leven*. The motionless subjects of such paintings tended to be food and kitchen utensils

to bring tulip bulbs back from Constantinople to Vienna, and in the 17th century tulips spread throughout Europe. In the Netherlands a veritable tulip mania ensued, aggravated by profiteering and botanical experimentation. The potential for creating hybrid strains seemed unlimited, and new varieties of tulip were dealt on the stock exchange (using painted images of the tulips) and resulted in wild speculation. In 1637 the Dutch tulip market crashed, and with it the financial well-being of many a small investor. Thus the tulip already had a famous, or notorious, history by the time Steen included it in his Delft bouquet.

If we take a careful look at the burgher of Delft's home, we realize that his house, with its window of flowers, does not fit in with the perspective alignment of this receding line of buildings. It is more to the fore, and seen more from the side. This is an error by the artist. But only by committing it could Steen satisfy the requirements that either he or the burgher from whom he had his commission had set: to place the head of the sitter in the middle of the composition, to leave the sitter squarely on his *stoep*, and still to present a panoramic view of the town.

We see clearly the special qualities of Steen's painting if we compare it with works by, say, his contemporary Rembrandt (1606–1669). Rembrandt liked to shroud his sitters in a dark, mystical aura. Instead of that aura, Steen prefers a profusion of concrete details. Through them he gives us a character portrait of the burgher and also of his city, showing the individual as a member of the society in which he lives and works.

on a tabletop, dead game birds and animals or a skull beside books, or, frequently, flowers in a vase. These pictures were notable for their relish of limited scope, and the closeness with which they scrutinized the things of the everyday world.

Steen places his vase on the window ledge and, in doing so, draws our thoughts toward the interior of the house. Well-to-do burghers felt that a presentable and indeed impressive interior, with carved chairs and tables, ornate mantelpieces, and floral decoration, was of great importance.

But perhaps the flowers are intended to point us not only to the interior but also to the person who must once have been there, the burgher's wife, now presumably deceased. The floral still life invariably prompted thoughts not just of beauty but also of transience. This miniature masterpiece on the edge of the painting may be a kind of memento mori, in remembrance of the dead. It is visible only to we who look at the painting. It is discreetly screened by the window shutter from the family members in the painting, who live entirely in the present.

The dominant flower in the bouquet is one that enjoyed extraordinary popularity in the Netherlands at that time. In the 16th century an Austrian legate was the first

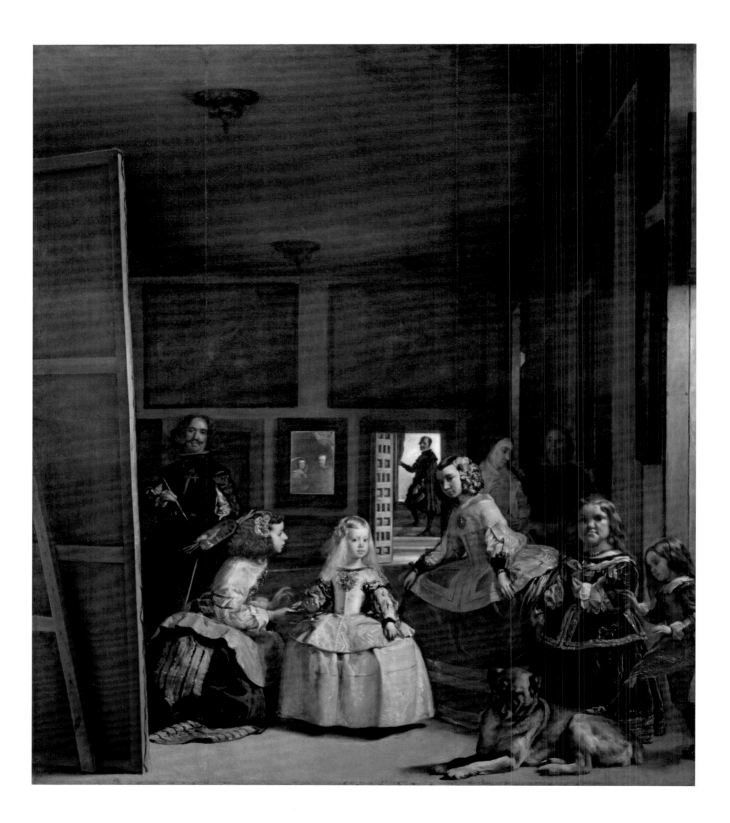

The end of the Habsburgs in Madrid

Velázquez and the Royal Family (Las Meninas), 1656/1657
318 x 276 cm, Madrid, Museo Nacional del Prado

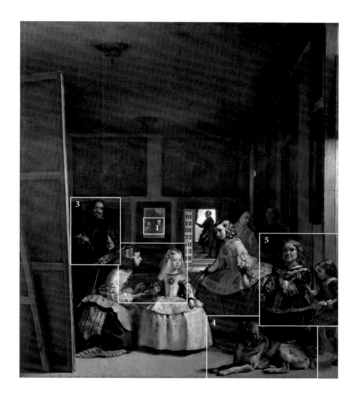

The scene: Velázquez's studio in the royal palace at Madrid. The artist is painting Philip IV and his queen, Mariana; the royal couple can be seen indirectly, reflected in the mirror at the rear. At the centre of the picture stands the five-year-old Infanta, Princess Margarita, who appears to have just come in with her maids of honour (las meninas) and other attendants. The light, and doubtless the gaze of her parents, are on the girl. Velázquez conveys an impression of family happiness, of wealth, and of a hopeful future, personified in the little princess.

The picture was painted in 1656/1657. At that date the king was 51, and in poor health; he had ruined Spain politically and economically; in reality the court's coffers were empty, in winter there was no firewood to warm the palace, and the fish served up on golden platters came stinking to the royal table.

The Habsburgs had been on the throne of Spain for five generations, and time and again they intermarried, within the family. The degeneration that resulted was most apparent in Philip IV, in his almost morbid weakness of will. Politically he was at the mercy of his first ministers, and in private life at that of his sensual desires. He is said to have fathered 32 illegitimate children, and had more mistresses than Louis XIV of France. Being a pious man, he felt that adultery was a sin. He wrote prolix, emphatic letters to a nun, confessing his sins and swearing to mend his ways; broke his word; swore his oath anew, and broke it again; and besought the nun to do penance on his behalf, with all the other nuns in her convent.

Philip IV had inherited an empire "on which the sun never set". But during his reign, Flanders was lost; Portugal and Catalonia cut their ties with Madrid; French armies ravished the country; and the routes to the colonies that produced silver were threatened by the growth of England's power at sea.

Under Charles I (of Spain, simultaneously Holy Roman Emperor Charles V) and Philip II, his great-grandfather and grandfather respectively, the vast Spanish empire had already become impossible to defend militarily, but it had come through, thanks to a combination of political skill, personal dedication, and the aura of Spanish power. Now all of that was gone. The reign of Philip IV proved one long chain of disasters.

Together with the empire, Philip had inherited the Spanish commitment to fight for a Catholic Europe – under Habsburg leadership. The Habsburg emperor in Vienna had abandoned that goal following the Thirty Years' War, recognizing that a Catholic monopoly on power was untenable. Philip IV never fully grasped this insight. He bled his country for the sake of a superannuated idea, disregarding the new realities. The older he grew, the more often he withdrew to El Escorial, the palatial mausoleum where the tombs of his great ancestors were. For hours he would pray, taking refuge in religious mysticism. To bear so great a burden of personal failure as Philip IV must exhaust or defeat the powers of any man.

An unhappy couple

There is no other Velázquez painting in which the king and queen appear together. This is the only one; and here, though united, they are unclear, mere apparitions. The fact was that they had little in common. Princess Mariana was 13 when she was sent from Vienna to Madrid to marry Philip. Then, she was a ruddy-cheeked, naïve girl who loved a good laugh, according to descriptions. One anecdote tells that, in

one of the towns her procession passed through, local artisans wished to make her a gift of a hundred pairs of stockings. The Spanish lord chamberlain spurned the offer in outrage, declaring: "A Spanish queen does not have legs!" Whereupon Mariana is said to have asked whether her legs were to be cut off in Madrid.

She did not lose her legs, but she lost very nearly everything else that makes the life of a young girl worth living. Corsetted into the strict ceremonials of life at court, she had nothing to do but make a majestic impression and, more importantly, bear an heir. Boredom, loneliness, homesickness, and illness in consequence of her never-ending pregnancies, transformed the lively girl into "that wilful, mulish German".

Philip gave her his attention for only a brief period. He was 30 years her senior, and her uncle. He had married the daughter of the emperor in Austria in order to consolidate the alliance between Madrid and Vienna – in vain. By 1656, the date of the painting, when the royal marriage was seven years old, hopes for an heir to the throne had still not been satisfied. Apart from the Infanta, Princess Margarita, Mariana bore an annual succession of stillborn babies. Subsequently she did give birth to two sons, who died in early infancy, and to a semi-retarded boy who in due course succeeded Philip IV on the throne of Spain, and put a miserable end to Habsburg rule in that country.

A well-bred Infanta

When this picture was painted Margarita was the royal couple's only child. The fact that she was there at all, and enjoyed good health, encouraged hopes of a male heir to the throne. The periodic ebb and flow of that hope should be borne in mind if we are to understand the light upon the girl properly. Unusually in one of her age, the five-year-old is grasping a jug so much as looking at the maid of honour. In this we can see the first fruits of a royal upbringing that em-

phasized self-control and awareness of one's station. Like most of the others in the picture, the Infanta is looking at the king and queen, whom we must imagine seated in front of the painting, as it were. Margarita is showing them how well she can already stand motionless, with a majestic manner. No doubt she already knows that a Spanish king or queen never laughs in public. This was something her mother had to be told, on the journey to Madrid. Her father was supposedly only ever seen to smile in public twice in his entire life.

The maids of honour (to either side of the Infanta) were chosen from the first families of the nobility. The one on the left is kneeling not in affection but because protocol requires her to. One had to kneel when proffering anything to a member of the royal family, and only very few were permitted to do so at all. Possibly it was the duty of the maid of honour on the right, who is dropping the hint of a curtsey, to fetch the jug:

everything involved more than one person. When the queen ate, her food was reached down a succession of ladies-in-waiting of rising rank, the last kneeling as she proffered it to the queen. No other European court of the period was so riddled with protocol and ceremonials. The protocol even increased as the realm declined: when everything is going under, you cling to etiquette.

Living by rules could be literally lethal, as a story told of Philip's father, Philip III, shows. He was sitting in his study, near a coal-burning stove. The coal was giving off too much heat, too much "vapour". But the noble equerry whose office it was to tend the stove was nowhere to be found. No one else dared attend to the problem. That night, the king fell ill, and died within a few days.

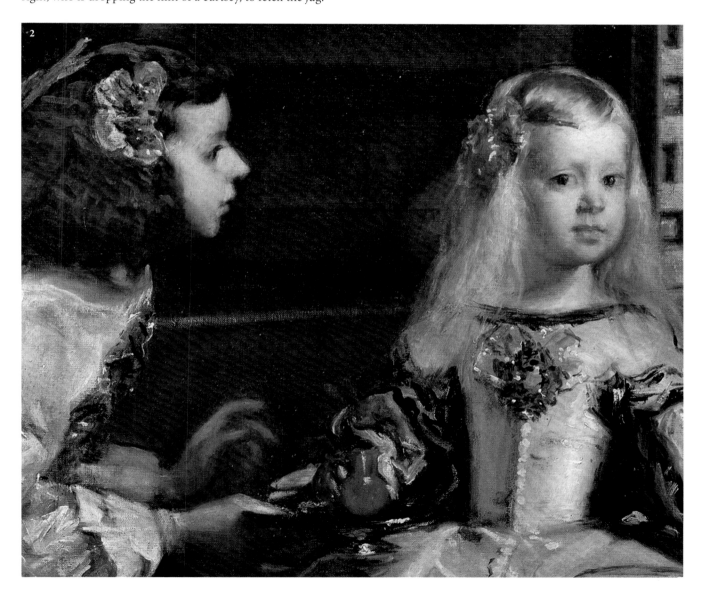

The dog and the "monster"

So that the rigid protocol and everlasting tedium of the palace might be a little more bearable, court jesters and dwarfs were part of the household. No other court in Europe had as many as the Spanish. Maria-Bárbola, the female dwarf, was from Germany; the young male dwarf at the far right, Nicolas de Pertusato, was from Italy. Both were members of the royal household. They had fool's licence, leading lives outside the court hierarchy, kept much as animals were. It is no coincidence that they are shown standing by the dog. Nor is it coincidence that Velázquez has allowed only one character in the picture a spontaneous gesture – the young dwarf is teasing the dog with his foot. Dwarfs were numbered amongst the "monsters" kept at a court, along with those suffering from water on the brain, physical deformities, or mental deficiencies. Maria-Bárbola, with her old woman's head on a childish body, was by no means the worst specimen. These people were dubbed "the vermin of the palace". Others, of normal stature, felt superior and attractive in the presence of the dwarfs; the "vermin" raised their self-esteem. The Infanta and her maids of honour are all the more appealing in the presence of Maria-Bárbola.

The end of a painter

Velázquez is wearing on his chest the Cross of the Order of Santiago; but in 1656/1657 he was not yet a member of the order. He was not inducted into it until three years later. First, a lengthy process had to establish the "purity" of his blood (no Jews or Moors were admitted); an exception had to be made because the details of his aristocratic ancestry were incomplete, an involved business; and more than a hundred witnesses had to confirm that he had never painted for money, but only for the delight of the king. Some other hand added the Santiago Cross at a later date.

It seems that membership of this exalted order, and thus climbing the human pyramid at the top of which stood the king, mattered at least as much to Velázquez as art. There are various pointers to this suspicion. The most telling is this: four years before painting *Las Meninas*, after having spent years performing largely honorific duties at court, which allowed him time to paint, he applied for the position of marshal of the royal household. He was an experienced courtier and knew

what this would entail. The position would be high in the hierarchy, but he would be bearing an oppressive burden of paltry tasks. Velázquez had to see to the king's bed linen, the straw palliasses of the guards, and the reed matting that covered the floors in winter; he had to procure firewood and coal; he had to superintend cleaning staff; at public banquets he had to hold the king's seat. A note in the 1657 archives reads: "Diego Velázquez, marshal of the royal household, reports that he is owed his salary for one year, a sum of 60,000 reals. The palace sweepers and other servants dependent upon his office have ceased to work, and, what is worse, there is not a single real to pay for firewood for His Majesty's chambers."

Even more exhausting than his duties in the palace were the tasks Velázquez had to perform when the court undertook its many journeys, to summer palaces, to theatres of war, or (in 1660) to the French border, where Philip gave his daughter from his first marriage to Louis XIV, to be his bride. In July 1660 Velázquez wrote: "I have returned to Madrid, worn out by journeying all night and working all day." A month later he was dead. In the last years of his life he scarcely painted anything at all.

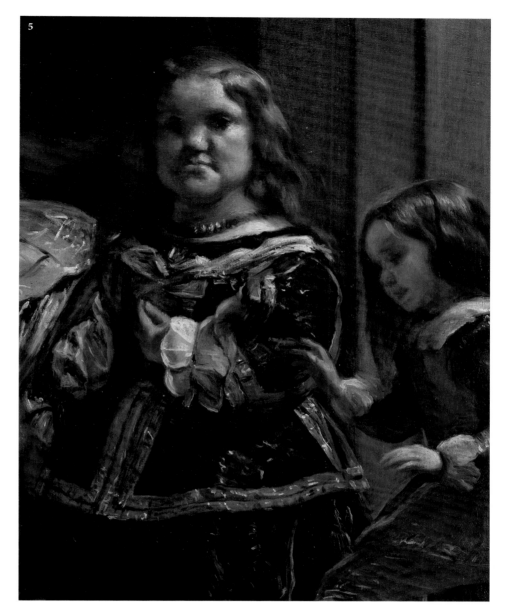

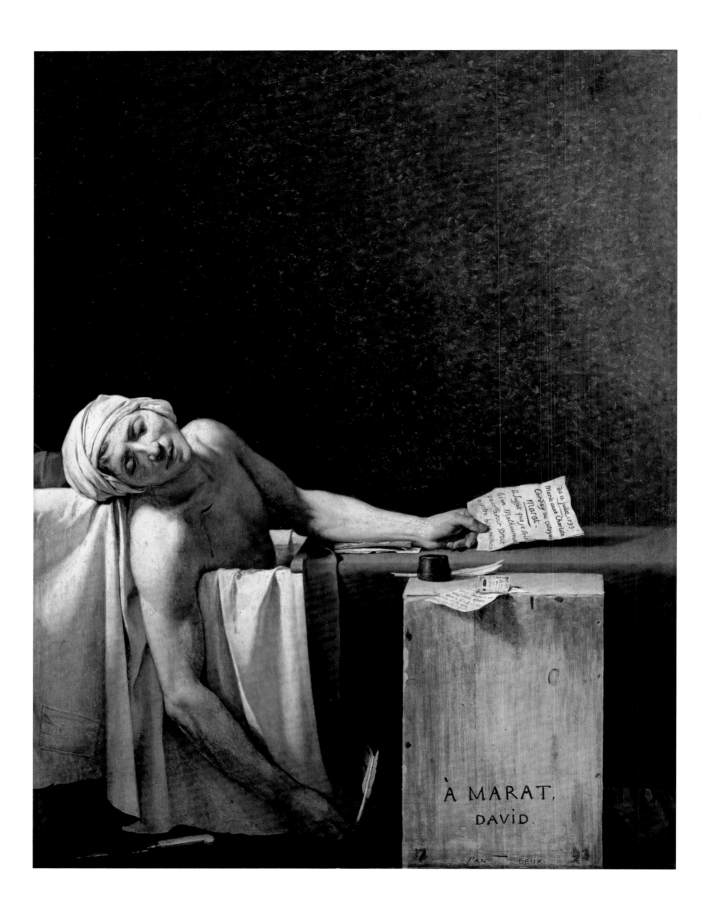

Jacques-Louis David (1748–1825)

The holy revolutionary

The Death of Marat, 1793
165 x 128 cm, Brussels, Musées royaux des Beaux-Arts de Belgique

*In 1793, a young aristocratic woman stabbed the Parisian journalist
Jean-Paul Marat in his bath: the French Revolution had its martyr. The painter
Jacques-Louis David was officially commissioned to turn the murder into
propaganda. His canvas, painted in a suitably "grand" manner, was completed
in the same year.*

David was not only a painter; he was the director of the Fête de la Revolution. The festival was a massive spectacle, conducted in the interests of political propaganda. Its organizers based their plans on the example of Roman Catholic ceremonies, providing magnificent displays, like those which had been put on to honour Renaissance princes.

Now that the princes had been deposed and beheaded, the churches closed and the priests driven away, the valuable experience they had accumulated in the field of propaganda and indoctrination was put to new use. David turned Marat's funeral into a particularly ostentatious campaign.

Naked from the waist up, his body was laid out in state in a former church so that anybody who wished could see the fatal wound. In front of the pedestal was placed his bath, the wooden crate that had served him as a table, and, on it, his inkpot and quill. The objects were displayed like holy relics. During the funeral procession, which ended at the Pantheon, a cannon resounded at five-minute intervals. The staging of the funeral turned Charlotte Corday's victim into a martyr: a saint of the Revolution.

David's festival displays are history, but many of his paintings have stood the test of time. His style was influenced not only by the Renaissance, but also by Classical antiquity. He had come to love Classical themes long before the Revolution. In 1784 he had painted *The Oath of the Horatii*, followed in 1789 by *Brutus and His Dead Sons*. Both works tell of the triumph of patriotism over individual happiness and family love.

Classical antiquity was à la mode, even in clothes fashions, but David's approach was more unremitting and he used Classical themes more convincingly than his contemporaries. He was a master of the "grand goût", as the "grand manner" of the day was called. He preferred large formats and grand gestures, leaving everything superfluous aside. Simple lines dominate; the structure is monumental. His works may be viewed from a distance, a quality also necessary for the success of a public spectacle.

Having tested his style on Classical themes, David turned his hand in 1793 to the depiction of a topical event: the death of Marat. He succeeded in turning a murder whose manner was far from "grand" – having taken place in a bathtub – into a painting of extraordinary political effect and artistic merit.

The sublime features of heroism

The French revolutionary Jean-Paul Marat was born in 1743 in the principality of Neuchâtel, which, at the time, was a Prussian enclave in Switzerland. His mother was Swiss; his father, a former monk, hailed from Sardinia. His son must have inherited his father's desire to preach, to instruct, to direct.

The writer Nicolas Restif de la Bretonne was strolling through the streets of Paris when he heard a shopkeeper talking to his neighbour: "She was about to flee. She was stopped at the door. He's dead." Soon, the whole town was buzzing with the news, and wherever he went, whether on the street or in cafés, the novelist heard "a hundred mouths talking of the terrible misfortune" that had befallen revolutionary Paris.

A girl from the provinces, Charlotte Corday, had murdered the Deputy Marat in his bath, where he had retired to relieve his skin trouble and to correct the galley proofs of his newspaper. It was the evening of 13 July 1793.

Jean-Paul Marat was one of the most popular revolutionaries. The poor, whose rights he defended in his newspaper *L'Ami du Peuple* (The Friend of the People), worshipped him. The royalists hated him, but in this they were not alone. The moderate supporters of the Revolution opposed him for his leading part in the "September massacre" of captured opponents of the Revolution. Naturally, he had also voted for the king's execution in January 1793. Jacques-Louis David had done no less.

Young Marat studied medicine and physics, writing a treatise on the spectral colours. Goethe later attested to his "insight and accuracy". However, his scientific work did not bring him the recognition which – in his opinion – he deserved. He remained poor. Feeling underrated, he saw himself as the object of unfair discrimination by envious colleagues. He also ruined his health by overworking.

The loner's radical ideas were undoubtedly a constant barrier to recognition. In 1774, 15 years before the Revolution, he published, in England, a tract entitled *The Chains of Slavery*, purporting to disclose "royalty's most unscrupulous attacks on the people". In 1789, during the first year of the Revolution, he founded the paper *L'Ami du Peuple* in Paris. Unlike most revolutionaries of the period, his ideas had been firmly established from the outset. It was against the background of these ideas that he judged all future events. As the self-appointed censor of political affairs, his intention was to use *L'Ami du Peuple* to "keep the National Assembly under surveillance, to disclose its errors, to guide it unceasingly back to the correct principles, to establish and defend the rights of citizens and to supervise the decisions of the authorities".

Initially, the Revolution was a bourgeois affair, a revolt against the king's financial sovereignty. The people stormed the Bastille, which brought them little benefit. "What use is it to us," wrote Marat, "that we have broken the aristocracy of the nobles, if that is replaced by the aristocracy of the rich?"

He fought not only against the royalists, but also against bourgeois revolutionaries and profiteers, making enemies on all sides. As a result, his paper was repeatedly banned and Marat hounded by the authorities. He fled, returned, hid in cellars. In 1791, the King himself was forced to flee; the supporters of a constitutional monarchy were done for. Marat became a Deputy at the National Convention. He saw terror as a legitimate revolutionary weapon: society must "be purged of its corrupt limbs!" he wrote. "Five or six hundred cut-off heads would have guaranteed… freedom and happiness… A false humanity… will cost the lives of thousands". Marat

warned that bourgeois forces would triumph, and he was proved right. He wrote that only a dictatorship could help to overcome the crisis of the Revolution, and Napoleon's rule confirmed his prediction.

It was his violent death which turned this controversial revolutionary into a national hero. David painted him with a gentle face; nothing in his features betrays the zealous demagogue. The painter wanted to portray the "sublime features of heroism and virtue", as he put it in conjunction with another painting, an artistic apotheosis of the first martyr of the Revolution, Lepelletier: "I shall have fulfilled my task if one day my work moves a… father to say: Look, my children, this was the first of your representatives to die for your freedom; see his features, how serene they are! That is because a person who dies for his fatherland is beyond all reproach."

Accessories as holy relics

A speaker at the National Convention calls upon David to paint Marat's portrait: "David, where are you now? Have you not passed down to posterity the image of Lepelletier dying for the fatherland? Now you have another painting to do!" Whereupon David answers: "Aussi le ferai-je!" The French words somehow contain more pathos than their English equivalent: "I'll do that too!"

David had visited Marat on the eve of his murder. He describes the wooden crate beside his bath. On it, he says, were ink and paper, "and his hand, stretching out from the bath, was writing his last thoughts for the welfare of the people… I thought it might be interesting to show him in the position in which I saw him last."

Marat was a sick man when he was murdered; he may even have been mortally ill. He had been unable to go to the Convention for weeks and had written very little for the newspaper. He had a constant fever and was tortured by a fearful rash. He sought to relieve his itching skin in water. He went back and forth between his bathtub and his bed, wound cloths soaked in vinegar around his head, took only fluid nourishment and drank inordinate amounts of black coffee.

It was David's task to portray this human wreck in a manner that aroused admiration. He removed all sign of skin disease and placed Marat's body in an imaginary space. In real life, the bathtub had stood before a papered wall with painted columns. Not so in David's painting. His largely dark background – taking up almost half the canvas – not only points to the frugality of Marat's ascetic way of life, but suggests that the space in which his figure is placed may be eternity itself. Its effect is reminiscent of the gold ground of medieval paintings.

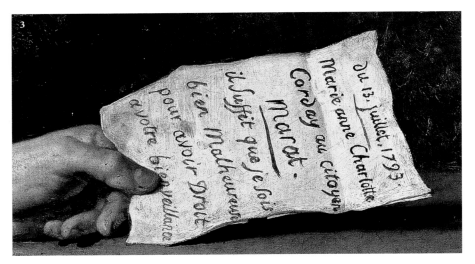

The letter and banknote in front of the inkpot were probably the artist's invention. The letter reads: "Give this banknote to the mother of five whose husband died defending the fatherland." At the trial which followed the murder an exact inventory of the objects found in the bathroom was read out; but the letter and banknote were not amongst them. David used them to portray Marat as a friend of the people. Marat's newspaper wrote that he had spent much of his time "hearing the complaints of numerous misfortunates and giving weight to their demands by petitioning on their behalf". The benefactor's own poverty – a wooden crate instead of a table, or the mended patch of cloth at the bottom left of the picture – emphasized his magnanimity.

David has painted Marat's body in a pose whose effect is particularly resonant: his limp arm hanging down, head lolling to one side and body half-leaning to face the spectator, supported under one shoulder, the white cloths – this pose had been used for centuries to portray Christ's descent from the Cross. Here, David was exploiting images that were stored in the public memory. He may also have responded to a widespread need for objects of religious veneration. His Man of Sorrows was Marat.

She bought the knife that morning

As one might expect, some contemporary pictures include the figure of the murderess. David's subject was not the drama of the murder, however; it was the awed hush that followed it. He painted an icon, in which feud, disorder and passion had no place.

The only signs of the murderess in the painting are the knife on the floor and the letter in Marat's hand. It reads: "13 July 1793. Marie Anne Charlotte Corday to the citizen Marat. It is enough that I feel unhappy for me to have a right to your goodness." Marat never received the letter, but Charlotte Corday had a similar note in her possession when she was arrested. The real letter did not include the word "goodness", however. Again, David has added it to underline Marat's philanthropism.

The murderess was 24 years of age at the time, and no less eccentric than Marat. Her full name was Marie-Anne Charlotte de Corday D'Armont. Her family were of impoverished aristocratic stock, but she had been brought up in a wealthy convent. She had become engaged to a man of noble, and equally impoverished, background. While he had joined the royalist cause, she supported the bourgeois revolutionaries. Her fiancé wanted to marry and emigrate; Charlotte refused. Patriotism may not have been her only motive, but it was certainly one of them. Following the Roman example, she declared the fatherland more important than personal happiness.

She might have found like-minded revolutionaries amongst the Parisian aristocracy, but in her native town of Caen there was nobody. She was ostracized and soon became estranged from her family. It was only when her father and an uncle who was a priest were forced to go into hiding, and when her fiancé and his brother were executed, that she turned against the increasingly bloody upheavals, deriding the "false demagogues… who drape themselves in the togas of people's advocates" to "establish tyranny and usurp the Republic".

She meant men like Marat who held the majority in the Convention and persecuted the moderates. Several moderate Deputies had fled to Caen, where they organized an uprising. However, when they called for volunteers to fight against the Convention, only seven men turned up. Charlotte Corday had made up her mind: "Surely we have not survived these four years of affliction only to allow a man like Marat to rule over France!" she exclaimed. "Too long have agitators and scoundrels been permitted to confuse personal ambition with the welfare of the people!"

She kept her decision secret. Buying herself a pair of good shoes, she took the mail coach to Paris on 9 July 1793, where she stayed the night at the Hôtel de la Providence. Her plan was to stab Marat to death at the Convention – hoping she would then be killed immediately by his supporters, thus maintaining her anonymity and avoiding any trouble for her family. She was disappointed to hear that Marat's illness had prevented him from appearing at the Convention for some time.

On the morning of Saturday, 13 July, she bought a knife; but she was turned away at Marat's door. She tried again that evening. Marat heard her voice and demanded that the unknown supplicant be admitted. She told him she had come from Caen. Marat then asked her about the Deputies who had fled there. Charlotte: "What do you intend to do with them?" Marat: "I shall have them all guillotined in Paris." According to Charlotte's later testimony, these words had sealed his fate.

Full of grand gestures, but no guts

Charlotte Corday was arrested immediately. Four days later, during the morning session, she was brought before a judge. That same evening she mounted the scaffold.

She had been "a Republican long before the Revolution," she explained to the tribunal, adding that she had killed Marat "because he embodies the crimes that are devastating the country". As for herself, she had "never lacked energy". "What do you mean by energy?" the presiding judge had asked. Energy, she answered, was a quality demonstrated by people who were "capable of setting aside their personal happiness and laying down their lives for their country".

Thus she went to her death, as "sublime" a heroine as any admired in ancient Rome. Insisting on a right to curiosity, she pushed away the executioner who wished to spare her the sight of the guillotine. She laid her head under the blade herself. It was not long before she, too, was hailed as a martyr – by moderates who abhorred the terror and defended the citizen's right to property. The royalists also championed her, generously overlooking the fact that she had been a convinced Republican.

David had acquired Marat's death mask for the portrait, and had Marat's bath, inkpot and the knife brought to his studio.

He wrote a modest-sounding dedication on the wooden crate in Roman style: "For Marat, David". At the same time, he painted his own name in letters that were not much smaller than the name of the dead hero. He dated the painting "Year Two", after the new revolutionary calender.

In October 1793, the painting was exhibited at his studio and in the courtyard of the Louvre. In November, he handed it over to the National Convention along with its pendant, the portrait of Lepelletier. "My colleagues, I offer you the homage of my paint brushes!"

The Convention had both works hung in the assembly chamber and – a demonstration of their blind faith in the future – passed a decree which prohibited future legislative bodies from removing the paintings.

By June the following year the moderates had taken power, sending Robespierre and about a hundred of his supporters to the scaffold. Sensing an imminent reverse in his fortunes, Robespierre had cried out in the Convention: "It remains for me to take hemlock!", an allusion to the death of Socrates. David, in a gesture as grand and noble as any ever seen in Rome, answered: "If you drink hemlock, then I shall drink with you!" When Robespierre was removed from power in a tumultuous session the following day, however, David stayed at home. He did not reappear until well after the radical revolutionaries had been executed and the authorities had grown weary of the guillotine.

Five years later, in 1799, the artist declared himself willing to complete an earlier, unfinished revolutionary work, painting over the real historical figures and replacing them with new ones "who have come to the fore in the meantime and will therefore be of far greater interest to future generations". No sign here of those celebrated Roman virtues! David had become a master in the art of adapting to new circumstances; it was not long before he was celebrating the new dictator, Emperor Napoleon. With the fall of Napoleon in 1814, however, David decided to go into exile. He took the Marat painting – removed from the Convention in 1795 – with him to Brussels. The portrait of Lepelletier entered the estate of his daughter, who, having meanwhile become a fanatical royalist, did away with it. It has not been seen since.

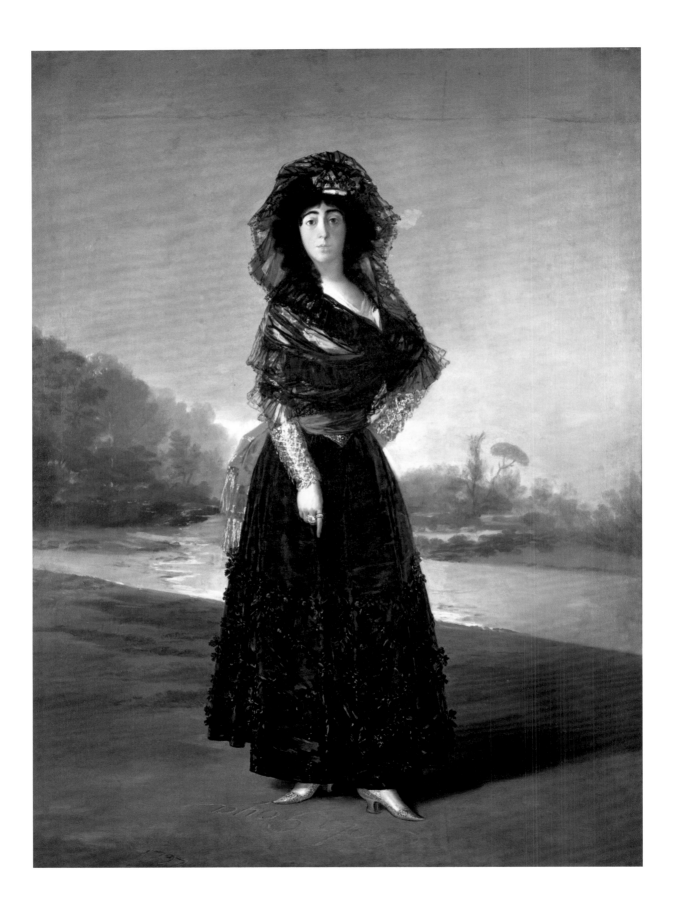

Francisco de Goya (1746–1828)

(full name Francisco José de Goya y Lucientes)

The black widow, beautiful and deadly

The Duchess of Alba, 1797
210.2 x 149.3 cm, New York, Hispanic Society

Later, he would draw her as a witch. Here, he has written his name in the sand at her feet. "Goya" also appears on one of her rings. Did the deaf painter have an affair with the assertive aristocrat? The portrait belongs to the Hispanic Society, New York.

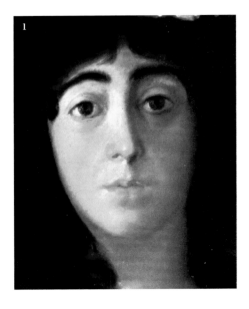

She is like a theatre star whose presence fills the whole stage. She needs no accessories, no props, no column to lean against, no tree to lend its shade. She stands alone before an almost monochromatic Andalusian riverscape. The solitude and confident pose are fully consistent with her character and social standing. Her name is Maria del Pilar Teresa Cayetana de Silva Alvarez de Toledo, 13th Duchess of Alba. After the Spanish queen, she is the first lady of the realm.

"Beauty, popularity, grace, riches and nobility", the Duchess of Alba had them all, as Lady Holland reported from her travels in Spain at the end of the 18th century. Other women envied her; the people worshipped her. The blind street singers, competing with the gazettes in Madrid, had almost daily news of the duchess's latest extravagances. They bantered about her rivalry with Queen María-Luisa, enlarging on the details of permanent squabbles about fashion and lovers, bullfighters and popularity.

Today, the Duchess of Alba and her scandals would be known only to a handful of historians, had she not met the artist Francisco de Goya. His relationship with the beautiful aristocrat gave rise to countless legends. During the 19th century, romantic novelists turned it into a passionate, and tragic, love story. In 1951, Lion Feuchtwanger made it the subject of a thrilling novel. But even he was forced to invent most of the plot, for very little evidence was left by either of them, or by anyone who knew them. Besides a small number of drawings and prints, the most important piece of evidence is a large (210 by 149 centimetre) portrait of the duchess, painted by Goya in 1797. It now belongs to the Hispanic Society in New York.

Even today, there is much that remains in the dark – the duchess's death, for example, five years after the painting was finished. A rumour circulating at the time suggested that she had been poisoned in the course of a quarrel with the queen. In a country that was traditionally dominated by men, both women were vastly superior to their husbands in vitality and strength of will. The Duke of Alba was as weak in character as he was in constitution. María-Luisa was so much more powerful than her phlegmatic husband, King Charles IV, that she had little trouble in transferring state power to her lover, Manuel Godoy, in 1792. However, the muscular thighs of the 25-year-old officer were generally thought to carry greater conviction than his powers of statesmanship. He was hardly the right man to guide Spain through the troubled waters of European politics.

A minority of Spanish intellectuals had immediately saluted the French Revolution in the hope that it would bring reform to a country that was badly exploited by its aristocracy and Church and was too backward to help itself. The execution of the French monarch, Louis XVI, had led to a half-hearted and unsuccessful Spanish expedition to avenge the affront. Soon, however, Godoy had not only concluded peace with revolutionary France, but had allied Spain with France against England. As a result, Spain was embroiled in war, including a civil war, for the next 20 years.

Initially, the Spanish grouping in favour of France and the Enlightenment had quickly grown in popularity. Its luminaries had met at the Salon of yet another formidable lady, Countess Benavente, where they had forged plans for a modern state modelled on the French example.

The majority of the population remained hostile to foreign ideas and customs, and a counter-movement soon formed in the Spanish capital to defend Old Spain. These conservative patriots made a great show of imitating the *majos* and *majas*, the simple townsfolk of Madrid, and of going to bullfights instead of visiting the Salons.

The highly aristocratic Duchess of Alba placed herself at the head of this plebeian movement. She put aside her French wardrobe and posed in a black skirt and lace mantilla, her hand resting provocatively on her hip. For a *maja* had to be *salada* ("salty"): ready to answer a risqué compliment with a snappy, equally brazen comeback. Her face should give nothing away, her bearing should be proud, with her head held high. This was the correct Spanish pose – whether for a backstreet *maja* or for a noble duchess.

As crazy as ever

Every hair on the Duchess of Alba's head arouses our desire," wrote one enraptured French traveller to Spain in the year 1796. In Goya's painting she appears petite and well-proportioned, with huge eyes under thick eyebrows and lush dark hair. To those who knew how to read it, the large black beauty spot beside her right eye symbolized "passion". Her dress, too, is predominantly black. This was appropriate both for a widow – the duke had died in 1796 – and for a *maja*. The effect is brightened only by her gold-lace sleeves, a short jacket, a white and yellow ribbon and a red sash.

Goya's painting does not capture the duchess's spontaneity. "What a lively, quick, gay person she was!" one elderly lady recalled. Visiting the duchess when they were both young, she had found her completely naked: "If it disturbs you to see me naked," the frolicsome duchess had exclaimed, "I shall veil myself with my hair."

The Duchess of Alba was 35 when she sat for the painting. She was therefore considerably younger and more beautiful than her two rivals, Countess Benavente and the queen. According to María-Luisa in a letter to Godoy, however, she was "still just as crazy as she was when she was a young thing". Her biographers see these "quirks" as deriving from her childhood and sterility.

Born in 1762 as an only child, she grew up in the various Alba palaces surrounded by nurses, governesses, footmen and court fools. Her grandfather, the Duke of Alba, was renowned for his arrogance. As his granddaughter was his only descendant, his desperation to secure the continuity of the family line drove him to find a husband for the girl while she was still very young. At the age of 13, she was married to the 19-year-old Duke of Villafranca. The bridegroom was bound by oath to take the name of Alba.

The young duchess proved unable to fulfil her most important dynastic task: to provide an heir for the house of Alba. Bored and frustrated, she plunged into a hectic life of engagements and amusement. Twentieth-century psychologists have diagnosed her as infantile, frigid, labile and narcissistic.

The duchess remained a spoilt child all her life, expecting her every whim to be gratified whatever the consequences for other people. She was as haughty as her forebears, but did not allow class prejudice to spoil her fun: she loved to ruin a man, or at least make a fool of him.

One of her jokes, for example, involved flirting with a seminarist on a street in Madrid: enticing him into a cake shop, she deliberately ordered so many of the most expensive delicacies that the poor young man was unable to foot the bill and, to the amusement of the (incognito) duchess, ended up pawning his trousers.

A top hat on a peasant's head

Francisco de Goya did not need to dress up as a *majo* – he was one, born and bred, even if the frontispiece of his *Caprichos* shows him wearing a top hat on his peasant's head. He was a *majo* whose genius, diligence and single-mindedness took him to the top of his profession.

Born in Saragossa in 1746, Goya was brought up in modest circumstances. After a knife-fight, the young painter is said to have led a life of adventure, roving from town to town. He may even have performed as a torero in the bullfighting arenas. Goya held a lifelong reputation as an expert on bullfights, returning to them again and again as the subject of his work.

Even after moving to the capital in 1774, where he received commissions from the Church, aristocracy and royal family, the artist remained true to his inquisitive mind and natural joie de vivre. He felt most at home drinking with the *majos* in the backstreet inns of Madrid. Like them, he loved flash clothes, music and dancing. A sturdy, carefree hedonist, Goya enjoyed drinking hot chocolate, partridge hunting and beautiful women.

Goya viewed painting above all as a craft which would bring him money and renown if he worked hard at it and knew all the right people. He had married into a respected family of painters and began work painting pictures for churches and providing large-scale cartoons for the royal tapestry factory. These mostly showed folksy scenes from the fashionable world of the Madrid *majos*.

Wealthy burghers and aristocrats soon began to commission portraits from Goya. Although his realism pulled very few punches, he was nevertheless concerned to produce representative works, rendering his sitter's dress and attitude in a manner befitting his patron's position in society. The work brought him into everyday contact with people who were well-educated and acquainted with world affairs, several of whom became his friends. It also opened new perspectives, encouraging the painter to think more critically about the world and his place in it.

In the 1780s, success came thick and fast. Goya became a royal painter in 1786, and three years later was nominated a court painter. He was celebrated effusively as the greatest of all Spanish painters. To crown his steep rise to fame and fortune he was to be elected to the coveted directorship of the famous Royal Academy at Madrid; suddenly, however, his solid and apparently secure existence collapsed.

In the years 1792 and 1793, the painter entered a period of crisis which took the outward form of a dangerous illness.

Francisco de Goya, frontispiece from the series *Caprichos*, Hamburger Kunsthalle

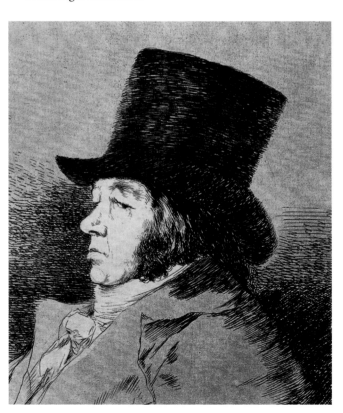

Travelling in the south, he arrived at Cadiz "in very bad shape" and was laid low in March 1793 at the house of his friend Sebastian Martinez. Symptoms mentioned in his friends' letters were "roaring in the ears", loss of balance, deafness. One of them wrote that it had been "Goya's imprudence which has brought him thus far". But beyond such remarks, very little is actually known.

By the end of 1793, Goya was back in Madrid. But he had gone stone deaf; not even the greatest noise could reach him. His illness, as well as the isolation deriving from his deafness, had turned the extroverted hedonist into a brooding sceptic who was tortured by bad dreams, evil demons and monsters.

It was apparently at this juncture in his life that the painter, now grown totally deaf, sickly and miserable, began his much-discussed "affair" with the Duchess of Alba.

Evidence of a romance?

As far as we know, Goya painted the Duchess of Alba for the first time in 1795. Besides his portrait of the duchess in a white dress, he had also painted her husband. In fact, the artist had belonged at the time to a circle around the artistically-minded countess of Benavente, one of his earliest patrons. The idea of drawing the artist away from the countess must have appealed to the duchess, whose protégés were usually actors and bullfighters. The manner in which she achieved this is recorded in a letter in which Goya tells a friend that the duchess came to him and asked him to make her face up, which "of course I enjoyed more than painting on a canvas". The context

of the letter helps date it to 1795; oddly, however, it is actually dated 1800, with a sender's address in London, although Goya had never been there. But this is by no means the only inconsistency in the affair.

It seems quite certain that the duchess and the painter spent several months in Andalusia in 1796/1797. At the time, Goya had undertaken a second journey to the South, while the duchess, following the death of her husband in June 1796, had retired to her estates for the statutory period of mourning.

The fact that they met there is evidenced by the portrait itself, with its date 1797 written in the sand. The background shows the flat riverscape around Sanlúcar. There, the family of the duchess owned a large estate with comfortable hunting lodges and country houses, an appropriately solitary retreat for a widow in mourning.

However, the ring held out on the duchess's finger is not a memento of her dead husband. Beside the jewel carved with the word "Alba" is a gold band with a clearly inscribed "Goya". Furthermore, her index finger imperiously draws the specta-

tor's attention down to the ground, where the words "Solo Goya" – "only Goya" – are written in the sand.

The word "Solo" was not rediscovered until the painting was restored several years ago. At some time or other, someone had gone to the trouble of painting it over, probably because the claim expressed in it by the artist seemed inappropriate, or compromised the sitter. In the foreword of a biography written in 1949, a later Duke of Alba expressed his opinion that an "ill-tempered, violent man" like Goya, whose "outward appearance was anything but refined, and whose language was extremely vulgar", could not possibly have become the lover of the sensitive duchess.

It is possible that Goya added the writing without the duchess knowing; if so, his painting may be a wish-fulfilment fantasy. On the other hand, it is worth consulting a book of sketches, made during Goya's stay at Sanlúcar. One of these, showing the duchess during a siesta, suggests a highly confidential relationship between them. The deaf, ugly genius Goya may well have been attractive to a woman of extreme inclinations who had a penchant for men of the lower classes.

"Flown"

Goya did not paint the duchess after 1797. Unlike her portrait in white, which is still in the Alba Palace at Madrid, the portrait of her in black did not enter her possession. According to an inventory made in 1812, the portrait was still in the artist's studio at the time.

With the division of the artist's estate following his wife's death, Goya's son inherited the painting. The artist must therefore have let it go, perhaps because it aroused such bitter memories.

The artist's disappointment is also suggested by the negative context of the duchess's two later appearances in his work, in the *Caprichos* (Caprices), published in 1799 and executed over a period of three years. A new, sceptical Goya expresses himself here in a series of about 80 satirical prints.

In one of the etchings, number 61, an unmistakable Duchess of Alba with outspread black mantilla flies across the sky like a witch on her way to the witches' sabbath where Goya assembled the demons and evil spirits who tortured him. Her white doll's face has an expression of haughty contempt; butterfly wings – symbols of fickleness – adorn her hair; three ugly figures, the bullfighters Costillares, José Romero and Pepe-Hillo, cower at her feet.

Goya wrote the caption "Volaverunt" – "They have flown" – under this etching. A savage form of leave-taking, perhaps?

The duchess died in 1802, at the age of 40. Immediately, some flimsy pretext was invented to justify impounding her estate. This gave the queen ample opportunity to purchase her dead enemy's jewels at their "estimated" value; Godoy, too, "bought" several of her paintings. Whatever remained after the estate was restored was shared out amongst the servants. A nine-year-old distant relative inherited the family name.

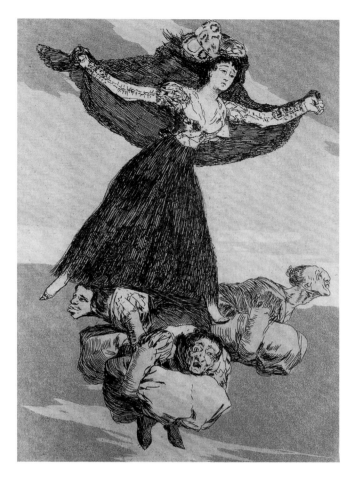

Francisco de Goya, no. 61 from the series *Caprichos*, Hamburger Kunsthalle

A rumour spread in Madrid that the duchess had been poisoned by her servants, or by "high-ranking people". The king was unable to avoid ordering an enquiry to ascertain whether or not she had died of "natural causes".

The person he entrusted with this extremely delicate task, in a letter dated 30 July 1802, was – of all people – the art-lover and prime minister Godoy. As is to be expected under these circumstances, the report he compiled has disppeared. There is an inexplicable gap in the royal archives, as there is in the Alba family archives, starting just after 30 July 1802.

With speculation remaining rife well into the 20th century, the Duke of Alba in 1945 was moved to throw light, by means of an autopsy, upon the mysterious circumstances of his ancestor's death. The pathologists discovered no sign of poison in the embalmed corpse; instead they found that somebody had hacked off the dead duchess's feet.[8] Oriental superstition attributed to this form of mutilation the power to prevent the return of the dead.

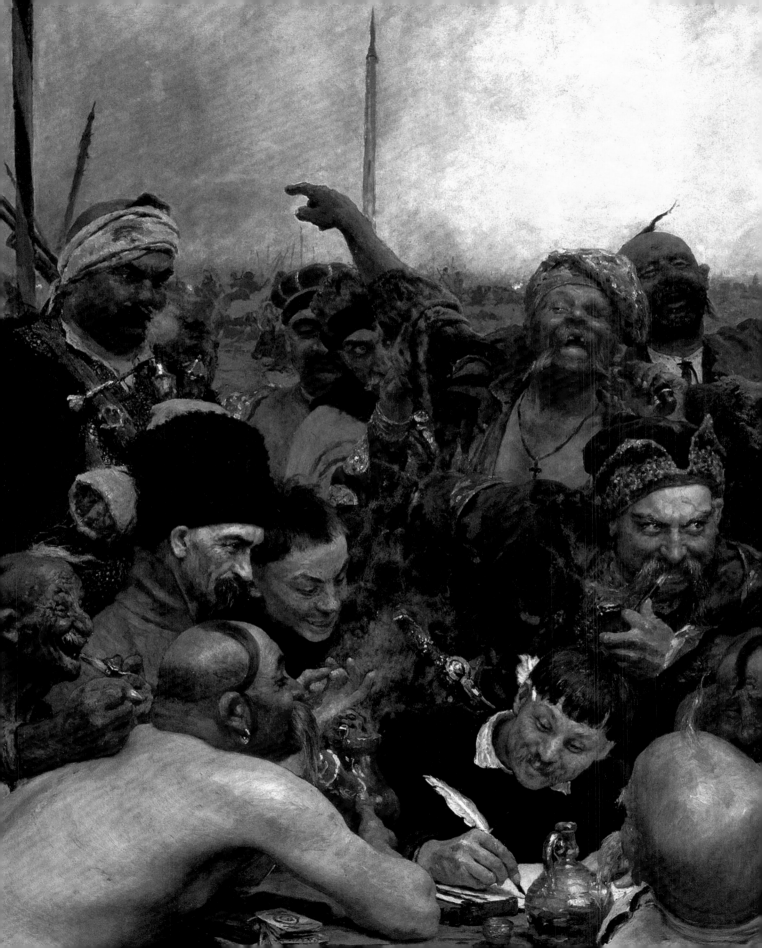

Ilya Repin (1844–1930)
(full name Ilya Yefimovich Repin)

Laughing struggle for freedom

*Zaporogian Cossacks Composing a Letter
to the Turkish Sultan, 1880–1891*
203 x 358 cm, St Petersburg, The State Russian Museum

*A sombre sky, uproarious laughter, Cossacks in their camp – a scene in 1676,
painted some 200 years later by Ilya Repin, the Russian realist. Cossacks, in Repin's
time, were considered "the symbol of Russian nature": the great writer Nikolai
Gogol, too, sang their praises, calling them a people "whose souls were like wide-
open skies, yearning for never-ending feasts and festivals." But all that belonged to
the glorious past, evoked as an antidote to the Tsarist dictatorship. Repin's painting
was a patriotic commentary on the contemporary scene.*

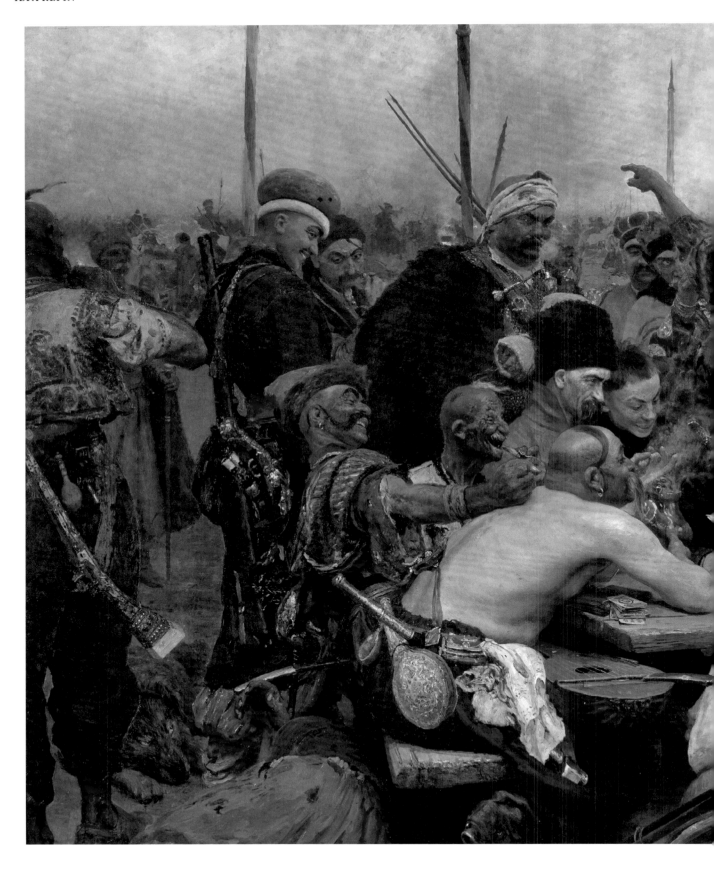

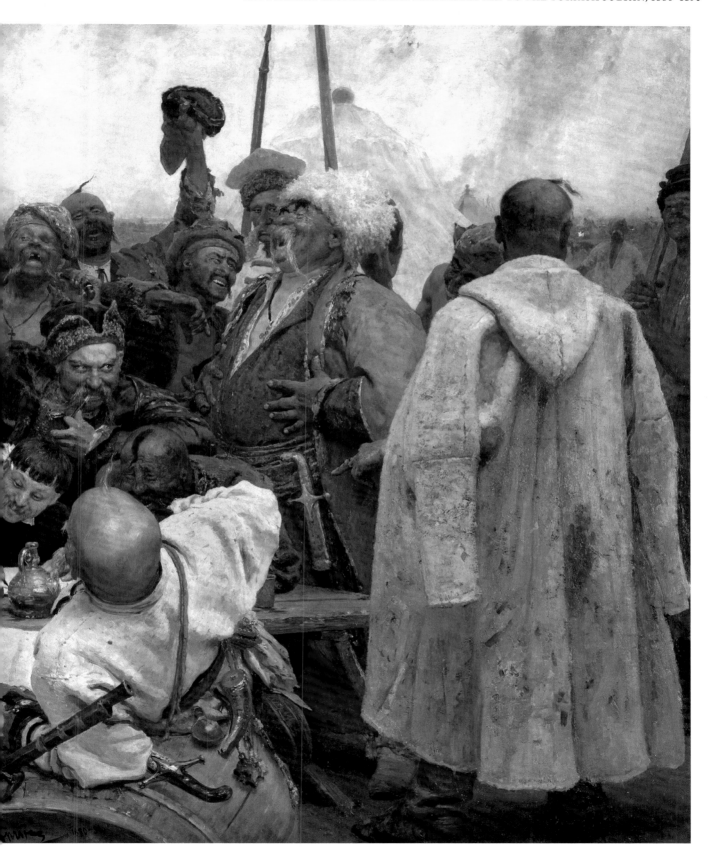

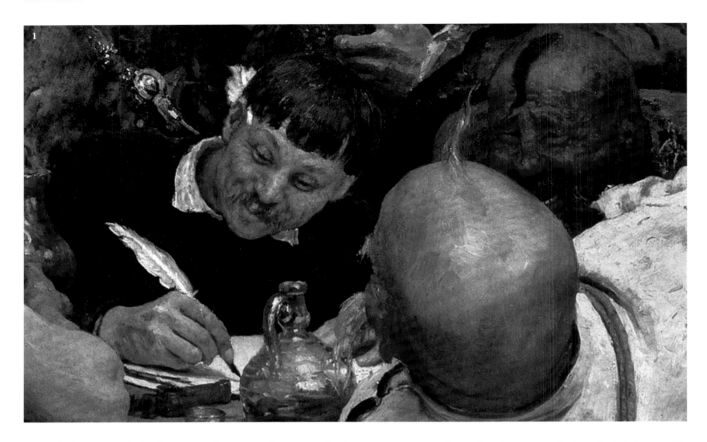

Cossacks have a symbolic function in Russia similar to that held by trappers, cowboys and pioneers in North America: they epitomize a heroic notion of freedom, their deeds and legends providing the stuff of which national identities are forged.

The Cossacks are not a nation, but the descendents of refugees who collected on Russia's southern borders from the 14th century onwards. To their east lay the Tartars, to their south the Ottoman Empire; Poland, Lithuania and the Russian state with Moscow at its centre lay to the north and west. They were thus surrounded. Initially, they included a large number of Tartars from whom they assumed certain characteristic features, such as their tufts of hair and bald heads.

However, it was first and foremost their form of government which distinguished the Cossacks from their neighbours. They were not ruled by princes, kings or sultans, potentates who endeavoured to bequeath their power to their heirs. Cossack leaders were elected for a limited term, and important issues were decided by a system of votes. The Cossacks had no wish to be anybody's vassals.

At first, the majority of these people lived along the banks of the Don and the Dnieper. Those who settled along the lower Dnieper were called Zaporogian Cossacks, after the Russian words *za porogi*: "beyond the rapids". In 1676 they defeated the army of the Turkish Sultan, who nonetheless demanded they submit to his conditions. In reply the Zaporogian Cossacks wrote a letter to the Sultan that was thick with insult: "For all

we care, you and your hordes can eat the Devil's shit, but you'll never gain an ounce of power over good Christians … you … pig-snouted mare's arse, you butcher's cur …" Stalin is said to have loved telling this story.

Not given to writing

Ilya Repin worked on his Cossack picture from 1880 to 1891, a fact noted at the bottom centre of his 203 by 358 centimetre painting. He thus showed an event which had taken place 200 years previously. The Cossacks had long since become subjects of the Tsar, their collective self-government stifled or replaced by imperial bureaucracy. They nevertheless retained a special status: treated as a caste of warriors, the state provided them with land and exempted them from taxes; in return, the men were expected to serve in the Russian army for 20 years, providing their own horses and equipment. In the 1880s they made up roughly a half of the Russian cavalry.

However, the enthusiasm for the Cossacks which abounded in Repin's time was not directed towards the contemporary warrior caste, but towards their ancestors. In Nikolai Gogol's story *Taras Bulba*, these early Cossacks are characterized by their love of freedom, fighting and festivities: "Their constant drinking, the way they threw care to the four winds, had something quite infatuating. This was no band of boozers drowning their sorrows, whining in their cups; this was untainted, untrammelled zest for life. Anyone who drew near felt its pull, left whatever he was

doing and joined them; the past no longer counted; sending care to the dogs he abandoned himself to the freedom and fellowship of spirits who thirsted for adventure like himself… whose souls were like wide-open skies, yearning for never-ending feasts and festivals. Here was the source of that unbridled joy …"

Nostalgic glorification of the ancient Cossack community was facilitated by the lack of contemporary documents. The Cossacks had compiled very few records before the 18th century. They were not given to writing. It was true that each hetman, as the Cossack captains were called, had a secretary at his side, but the latter's abilities were employed almost exclusively for external correspondence. There were no registers of birth, marriage or death, no written laws, no lists defining privilege. This was not due to inability, but conviction: the Cossacks thought of written documents as dangerous instruments of oppression; they had probably learned as much at the hands of both the Turks and the Russians.

A contemporary of Repin, the Russian anarchist Mikhail Bakunin (1814–1876), was of a similar mind. According to Bakunin, the first aim of an insurrection should be to set fire to the town halls, for it was here that the "paper empire" stored its documents, which must be annihilated if a fresh start were to be made. Criticism of the unwieldiness and corruption of Russian bureaucracy came not only from reformers and revolutionaries. On the contrary, it was so widespread that the notion of a society in which men took matters into their own hands and then "abandoned" themselves to "freedom and fellowship" found admirers even at the Tsar's court in St Petersburg.

Every detail counted

Some of Repin's contemporaries wrongly imagined that the artist was of Cossack descent. Flattered, he rejected the proposal, referring to it in the first sentence of his memoirs as "a great honour indeed". The full extent of his admiration for these people was made evident in 1881 by his four-year-old son, whose head, in accordance with contemporary custom, Repin had shaved, while insisting at the same time that a single tuft of hair be left in place – a tradition that had practically died out even amongst Cossacks.

Ilya Repin was from the Ukraine, one of the original Cossack homelands. He was born in 1844 in a military settlement: an arrangement whereby peasants were given land by the state in return for providing billeted soldiers with food and lodging. The situation was not unlike that found in Cossack villages. Repin's father had been an ordinary soldier.

Owing to his extraordinary talent, Repin was accepted into the Imperial Academy of Arts at St Petersburg, which also paid for him to travel abroad in 1872, visiting Paris in 1873. On his return to Russia he lived in St Petersburg and Moscow, though he travelled constantly throughout the land, always on the lookout for interesting people and subjects, or searching for signs of the supposedly glorious Cossack era of yore.

By contrast, Cossack life in contemporary Russia was hardly uplifting. Their former martial spirit was sapped by loss of in-

dependence as a warrior people. Moreover, they had become intellectually and economically backward. When the railway reached the Don, for example, the Cossacks demanded it bypass their town for fear the tracks might hinder their access to grazing land. The horses and the animals they kept for meat were more important to them than industrial progress.

If the Cossacks held by their traditional way of life, they also made much of ancient superstition, a phenomenon Repin experienced on several occasions. The further he penetrated into the Russian interior to sketch Cossacks for his paintings, the more frequently he met with rejection from a people who feared forfeiting their soul to the devil by allowing themselves to be painted.

Repin also had difficulty finding authentic clothes, weapons and other objects. As a realist, he was unwilling to improvise, and yet a cultural anthropology worth the name, whose collection and study of utensils might have facilitated his project, was still in its infancy. He was forced to give up, and it was not until 1887 when he found a scientist who owned a collection of Cossack artefacts that he decided to resume painting. He was by no means alone in his interest in things ancient. Amongst the nobility and the thin band of the middle classes was a movement whose aim was to promulgate whatever was truly Russian or

Slavic against the strong influence of Western Europe, and which sought to establish, by prosecuting indigenous tradition, a new sense of pride in all things Russian. For Repin, too, there was more at stake than realism or historical accuracy: "What I feel in each tiny surviving detail of that era is an unusual form of spirituality, a kind of energy; it all seems so rich in talent, so vigorous, so replete with liberal social significance … The freedom of our Cossacks, their chivalry, I find quite delightful."

Hilarity on canvas

The oppression of women was part of Cossack freedom. Not a single woman appears in Repin's picture, a detail that may simply reflect the reality of a military encampment, but which is also in keeping with a widespread opinion which held that women, to a Cossack, were there for work, lust and beating. This, at least, was the view presented by writers like Gogol, or in Sholokhov's novel: *And Quiet Flows the Don*. "Don't listen to her blether, my boy, she's a woman and doesn't know what she's talking about…", says Gogol's Taras Bulba. Or: "… stop your whining, woman! A Cossack shouldn't need to worry himself with females!"

The weapons, fur hats and coats in the picture also evoke a life of freedom under "wide-open skies". During the 16th century Siberia was penetrated by Cossacks who kept Moscow supplied with valuable animal skins and furs. In the 19th century it was Cossacks again who defended Russia's Asian borders. They settled in places as far apart as the Dnieper and the Pacific coastline, 5,000 miles to the east, where, far from Moscow and St Petersburg, they retained some of their original autonomy.

Russia's old rivals to the south were still strong, and the Russians needed to secure access to the Black Sea and weaken Turkish influence in the Balkans. However, the Crimean War (1853–1856) ended in Russian defeat – an outcome which admittedly owed more to the action of the British and French than that of the Turks – and notwithstanding their victory in the Russo-Turkish War of 1877/1878, the Russians did not achieve their aims. Repin painted his Cossacks at a time when the Russians considered the Turks their sworn enemy. For many years, Russian soldiers had gone into battle not only for their own country, but to defend Christendom against the encroachment of Islam.

Repin saw the 17th-century Cossacks in a similar light: "It was here that certain intrepid elements within the Russian people spurned a life in comfort to found a community of equals whose purpose was the defence of those principles most dear to them – Orthodox worship and personal freedom. This may seem old-fashioned by today's standards, but at that time, when thousands of Slavs were made slaves by the Muslims, it was an exhilarating prospect." According to Repin, the Cossacks "defended the whole of Europe" and "laughed heartily at the arrogance of the East."

Repin's history painting contains a wealth of reference to his own time. Contemporary relevance was, by definition, part of the genre. The history painting provided a vehicle by which the past could speak to the present in a manner edifying to moral and national sentiment. It was considered the highest branch of art throughout Europe, and its themes were nobility and heroic grandeur.

There is no indication that Repin or his contemporaries noticed that the letter-writing scene contained something quite unusual in art: laughing men. One may search far and wide in museums of European art before finding a scene with figures who are not simply smiling or grinning, but laughing aloud; and one is even more unlikely to find such a scene in a history painting. Hilarious laughter may be in keeping with an occasion where men invent a series of increasingly rude insults; it does not consort well with the dictates of a genre expected to awaken feelings of a more solemn nature.

This, at least, may initially seem to be the case. To the contemporary spectator, however, the story taken up by Repin's painting was part of traditional lore; they knew the artist did not merely wish to portray superficial amusement. Repin was concerned to show the latent vigour of the Russian people, a force which, put to proper use, could defeat both external aggressors and the bureaucracy.

In search of Russia

When Repin became acquainted with the letter of the Zaporogian Cossacks in 1878, the final year of the Russo-Turkish War, he immediately began a sketch. Two years later he travelled to the Ukraine to collect further material, starting work on the painting itself in October 1880: "It all happened by accident – I was unrolling a canvas and then suddenly I just

couldn't stop myself picking up a palette and starting work … Everything Gogol wrote about them is true. A hell of a people! No one in the world has drunk so deeply of liberty, equality and fraternity!"

In 1881 Tsar Alexander II was assassinated by revolutionaries. Repin attended their execution and witnessed the reprisals meted out by Alexander III: "What dreadful times were those … We lived in constant fear …" He set aside his half-painted canvas with its scene of hilarity and did not return to it until 1889, after a further research trip. He had considerable trouble completing the work: "Working on the harmonic proportions of the painting … I have been forced to leave out some things and alter others – both colours and figures."

The colours in the final version of the painting are restrained, contrasting soberly with the sheer vitality of the figures and stark crudity of the letter. Moreover, Repin paints a cloudy, grey, sunless sky. Most of his paintings are sombre in this way. "The Russian national scene is grey, even when the weather is fine. Let it be grey then, not pink or sunny or joyous blue!" Thus the demand of a Russian art critic in 1892, one of Repin's friends. His article castigates the imitation by Russian artists of Western styles and colours and draws a comparison with Russian literature: "Pushkin, Turgenev and Tolstoy's literary colour was powerfully grey, powerfully Russian. Only if Russian art takes a leaf out of their book will it attain the high distinction of Russian literature."

It had been clear to Repin ever since his first period abroad, after completing his studies at the Academy, what he wanted from art: to paint Russia. He had found little to interest him in the Paris of the Impressionists, nor did he share the French artists' enthusiasm for light and atmosphere; it was not a new technique he was searching for, but his own subject. His great wish was "to study what is truly ours", he wrote; for the "study of the idiosyncrasies" of the Russian people "had barely begun".

It was a planned retrospective of his work at St Petersburg in 1891 that finally made Repin complete the work. "All those legends, stories, memories, even Taras Bulba himself – it all came back …", enthused one of Repin's artist friends. It is unlikely that a man like Alexander III, whose fear of revolutionaries turned Russia into a police state, really understood the painting's apotheosis of the Cossack sense of freedom. He may have felt drawn to pugnacious and powerfully-built men who were able to hold their liquor simply because that was the kind of man he was himself. Whatever the reason, he purchased the painting – now in the State Russian Museum, St Petersburg – there and then, paying the handsome sum of 35,000 rubles: apparently, the highest sum hitherto paid to a Russian artist for a single work.

Credits

The publisher would like to thank the following museums and archives for giving permission to reproduce the works in this book. Unless stated otherwise, the copyright for the illustrated works is owned by the collections and institutions listed in the picture captions, or by the archives of the publishing house.

6-13: © bpk | Scala
14-19: © Photo Hugo Maertens
4, 20-27: © 2017. Photo Scala, Florence - courtesy of the Ministero Beni e Att. Culturali e del Turismo
28-35: © National Gallery, London / Bridgeman Images
36-41: © 2017. Photo Scala, Florence - courtesy of the Ministero Beni e Att. Culturali e del Turismo
1, 42-49: © Bridgeman Images
50-55: © bpk | RMN – Grand Palais | René-Gabriel Ojéda | Thierry Le Mage
56-63: © Museo Nacional del Prado, Madrid
2, 64-69: © Rijksmuseum, Amsterdam
70-75: © Museo Nacional del Prado, Madrid
76-81: © Musées royaux des Beaux-Arts de Belgique, Brussels
82-87: © The Hispanic Society of America, New York

Imprint

EACH AND EVERY TASCHEN BOOK PLANTS A SEED!
TASCHEN is a carbon neutral publisher. Each year, we offset our annual carbon emissions with carbon credits at the Instituto Terra, a reforestation program in Minas Gerais, Brazil, founded by Lélia and Sebastião Salgado. To find out more about this ecological partnership, please check: www.taschen.com/zerocarbon
Inspiration: unlimited. Carbon footprint: zero.

To stay informed about TASCHEN and our upcoming titles, please subscribe to our free magazine at www.taschen.com/magazine, follow us on Twitter, Instagram, and Facebook, or e-mail your questions to contact@taschen.com.

© 2018 TASCHEN GmbH
Hohenzollernring 53, D–50672 Köln
www.taschen.com

Editorial Coordination: Meike Nießen, Cologne
Design: Birgit Eichwede, Cologne
Production: Tina Ciborowius, Cologne

Printed in Slovakia
ISBN 978–3–8365–6976–7

PAGE 1
George Gower
Armada Portrait of Elizabeth I (detail), c. 1590
Woburn Abbey

PAGE 2
Jan Steen
The Burgomaster of Delft and His Daughter (detail), 1655
Amsterdam, Rijksmuseum

PAGE 4
Andrea Mantegna
Ludovico Gonzaga and His Family (detail), c. 1470
Mantua, Palazzo Ducale